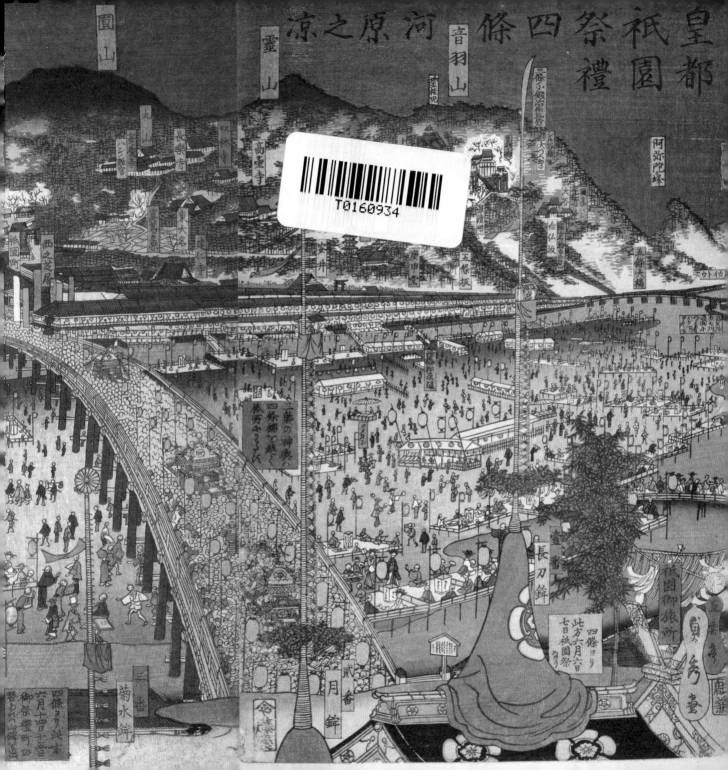

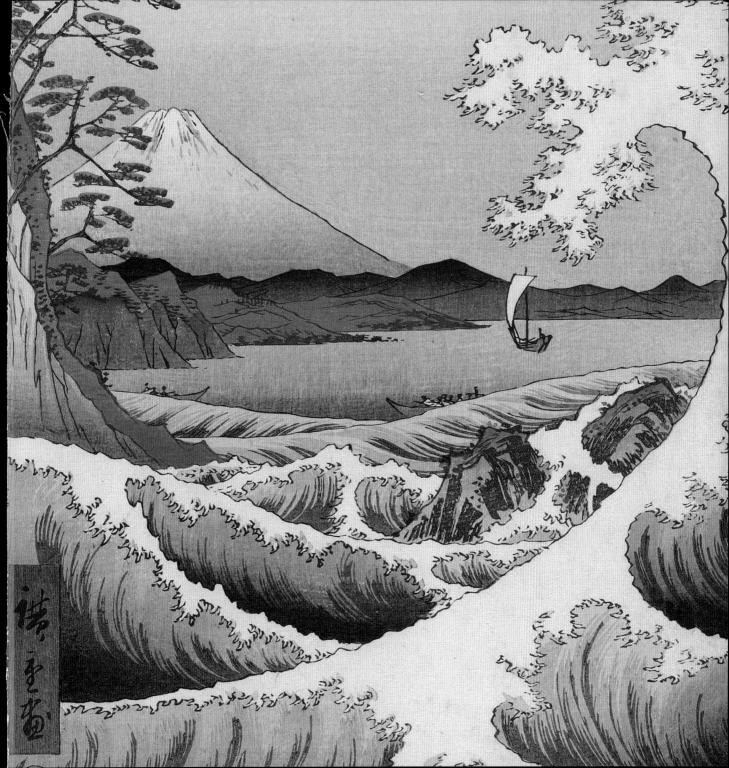

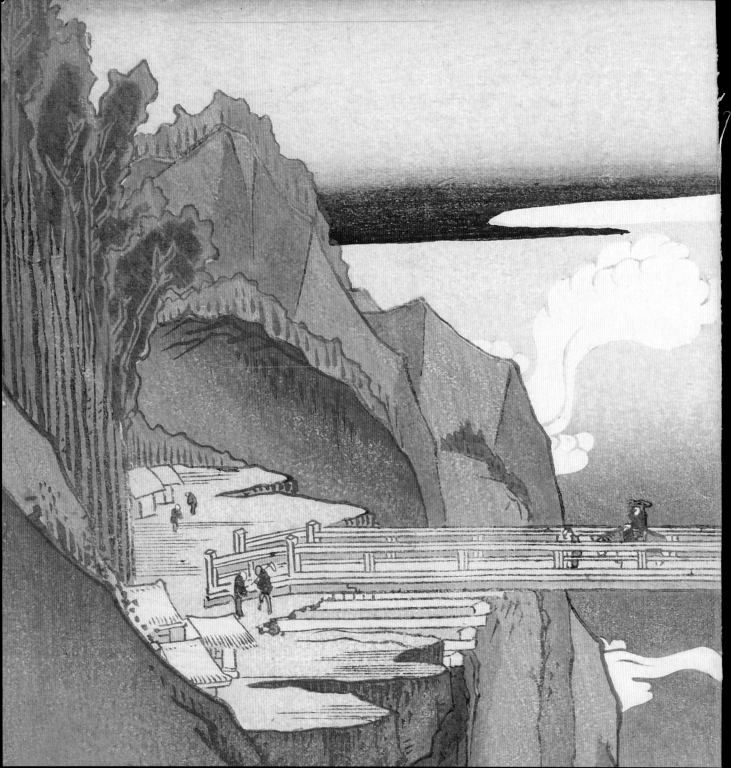

Japan Journeys

FAMOUS WOODBLOCK PRINTS
OF CULTURAL SIGHTS IN JAPAN

ANDREAS MARKS

TUTTLE Publishing

Tokyo | Rutland, Vermont | Singapore

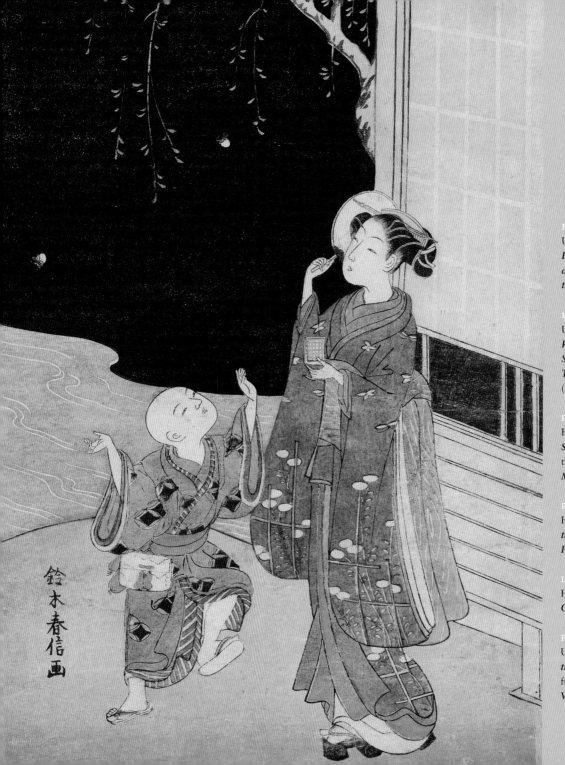

鈴木春信画

Contents

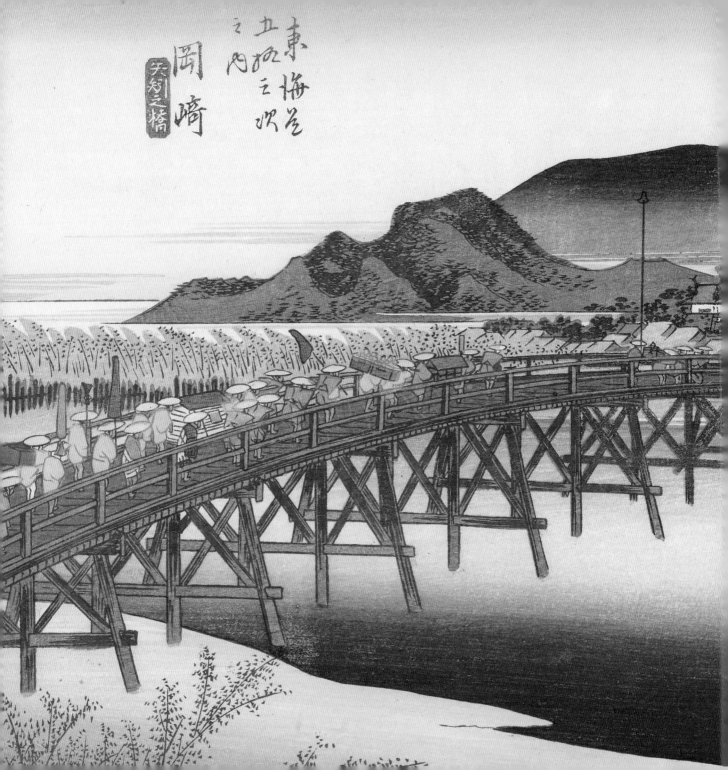

A Paradise for Travelers

I n nineteenth-century Japan, after centuries of civil war and restrictions on individual mobility, travel became a popular leisure activity, thanks in part to the development of a network of well-built and fairly safe roads. Instead of a rough ordeal into the unknown, traveling was expected to be pleasurable and to provide opportunities to experience culinary and cultural specialties, local color, and other entertainments. This new interest in travel and enjoyment of local culture is reflected vividly in the woodblock prints of the period. Prints featuring the natural beauty and architectural riches of various regions of Japan started to gain widespread popularity by the 1830s, giving birth to a new category of print that served as an affordable memento for travelers. Thus historic views of Japan's favorite sights have been preserved over the generations, offering a fascinating perspective on familiar cultural icons for tourists both domestic and foreign today.

TRAVEL AND PRINTS

The origin of the travel boom in Japan is found in the pilgrimages to sacred sites that became widespread among all classes during the nineteenth century. Accurate statistics of domestic tourism at this time do not exist, but it is estimated, for example, that as many as five million people participated in the 1830–1831 mass pilgrimage

FACING PAGE The procession of a feudal lord crosses Yahagi Bridge towards Okazaki, whose castle, birthplace of the founder of the Tokugawa shogunate Tokugawa Ieyasu, is in the background. Ca. 1832–1833, Utagawa Hiroshige, *Okazaki: Yahagi Bridge* (detail), from the series *The fifty-three Stations along the Tokaido.*

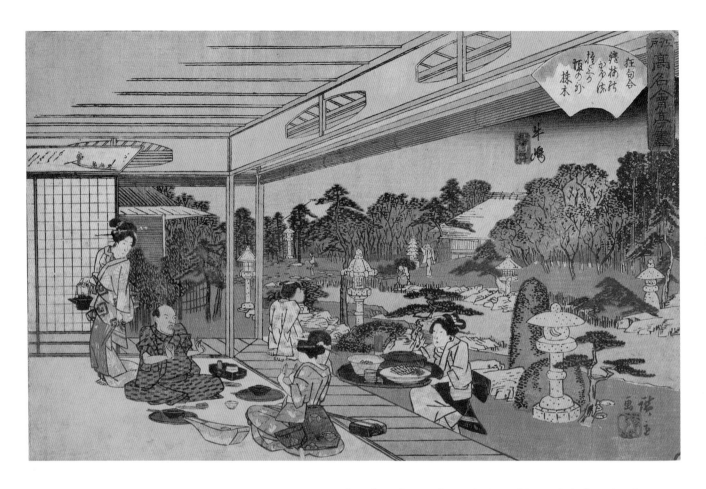

ABOVE The customer seated on the left, playing the popular parlor game *ken* with a woman, is believed to be Hiroshige himself. Ca. 1838–40, Utagawa Hiroshige, *Musashiya Restaurant in Ushijima* from the series *Collection of Famous Restaurants in Edo*.

to Ise when the total population of Japan is believed to have been 32 million. To facilitate the growing number of travelers, lodging and dining opportunities, as well as other services, were established, especially along the main arterial roads like the Tokaido highway that connected Edo (today's Tokyo) with Kyoto. This interest in travel and depictions thereof was further bolstered among the masses by travel stories like the bestselling serial novel by Jippensha Ikku (1766–1831), *Strolling Along the Tokaido*, also known as *Shank's Mare* in English.

By shogunal decree, with very few exceptions, Japan had limited contact with foreign countries until the 1850s, when the American navy forced Japan to open its doors to the West. This opening was swiftly followed by an unparalleled modernization and Westernization in the late nineteenth and early twentieth centuries. The development of railways facilitated rapid urbanization and along with that came a shift away from traditional lifestyles.

In the twenty-first century, when social networking has created a demand for a constant photographic recording of one's life, the urge for documentation is especially apparent in the behavior of tourists, where excessive photographing and digital sharing seems to have largely replaced the once obligatory postcard writing. An obsession with capturing scenes visually has always been noticeable in Japan: in the late twentieth century, the camera-wielding Japanese tourist was a common stereotype worldwide. This interest in documenting travel is not new, and is one of the reasons why thousands of different views of Japan's scenery were offered as commercially produced woodblock prints in the eighteenth and nineteenth centuries. Such prints were attractive not just as a memory of a past trip but also as a visualization of a desired future journey. Today they allow us a glimpse of life at that time and provide also an image of the scenery then, although we should keep in mind that views of remote locations weren't necessarily accurate representations but rather idealized interpretations by artists who usually did not have the opportunity to actually see these places with their own eyes. Instead, they often based their pictures on illustrations in travel guidebooks.

Two artists were especially successful in designing landscape prints and have received substantial international recognition over time: Katsushika Hokusai (1760–1849) and Utagawa

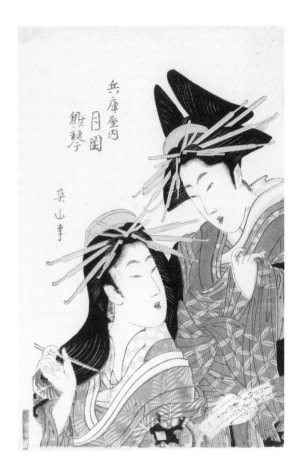

ABOVE Geisha and courtesans are seen by many as cultural icons associated with a traditional Japanese lifestyle. Ca. 1815, Kikugawa Eizan, *The Courtesans Tsukioka and Hinagoto of the Hyogoya.*

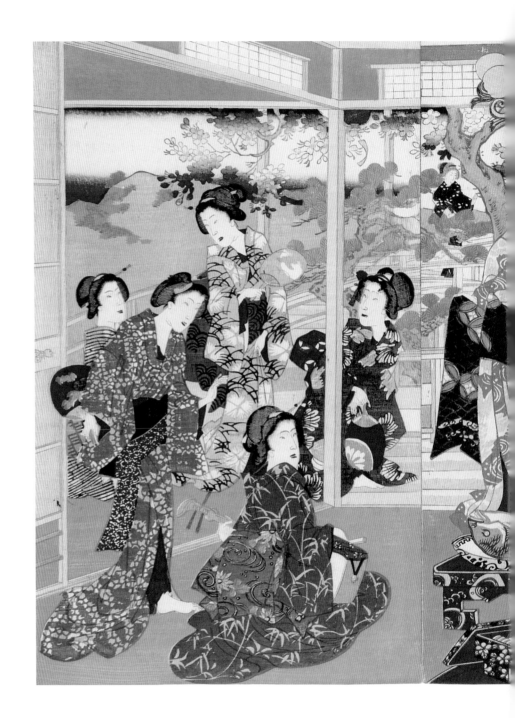

RIGHT Ikaho is a hot spring resort in the center of Gunma Prefecture, located near the foot of Mount Haruna. 1883, Toyohara Chikanobu, *Ikaho Spa, Foreigners at a Festive Meal with a Bath House in the Background*.

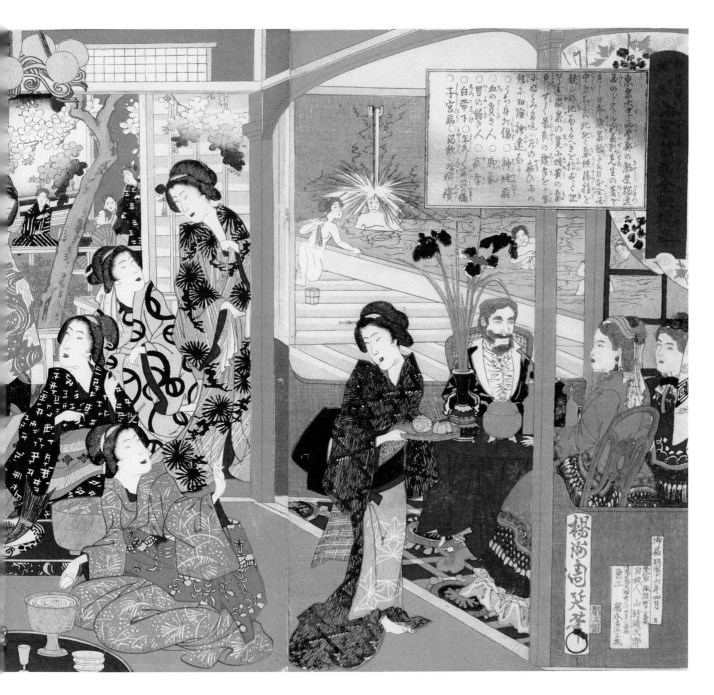

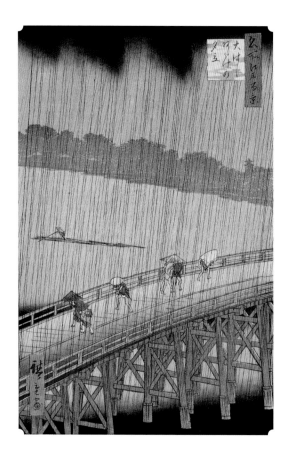

ABOVE This highly esteemed print was copied in 1887 by Vincent van Gogh in oils. 1857, Utagawa Hiroshige, *Sudden Shower over Shin-Ohashi Bridge and Atake,* from the series *One Hundred Famous Views of Edo.*

FACING PAGE Women walk in the snow to a backdrop of one the aqueducts that supplied Edo's water. 1853, Utagawa Hiroshige, *Ochanomizu* (detail) from the series *Famous Places in Edo.*

Hiroshige (1797–1858). Hokusai created an enormous output of several thousands of highly original prints, paintings, sketches, and book illustrations. Since around 1800, he regularly designed landscape prints and significantly influenced the genre, first and foremost with his print series *Thirty-six Views of Mount Fuji* from ca. 1829–1833.

Hiroshige's first landscape prints appeared in the early 1830s and he subsequently became the leading landscape artist. He was especially known for several series he did depicting sights along the Tokaido road, the earliest and most famous of which is generally known as *Tokaido published by Hoeido,* and was issued ca. 1832–1833. The print entitled *Hara: Fuji in the Morning* on page 111 is an example from this series. Hiroshige was equally successful with views of famous places in Edo, such as his final series of masterworks, *One Hundred Famous Views of Edo,* published from 1856 until 1858 of which many examples are shown in Chapter One of this book. The city of Edo was by far the most popular scenic motif in the nineteenth century and woodblock prints that feature the city include depictions of the important and popular roads, rivers, bridges, shrines, and temples, featuring them at specific times of the year, such as spring wisteria blooms at the shrine at Kameido, or summer fireworks on the Sumida River. Many of the Edo locations featured in this book are still tourist attractions today, although other areas, such as the electronic mecca of Akihabara and the nightlife district of Roppongi were established after the Second World War and are not featured in the woodblock prints of the eighteenth, nineteenth, and early twentieth centuries.

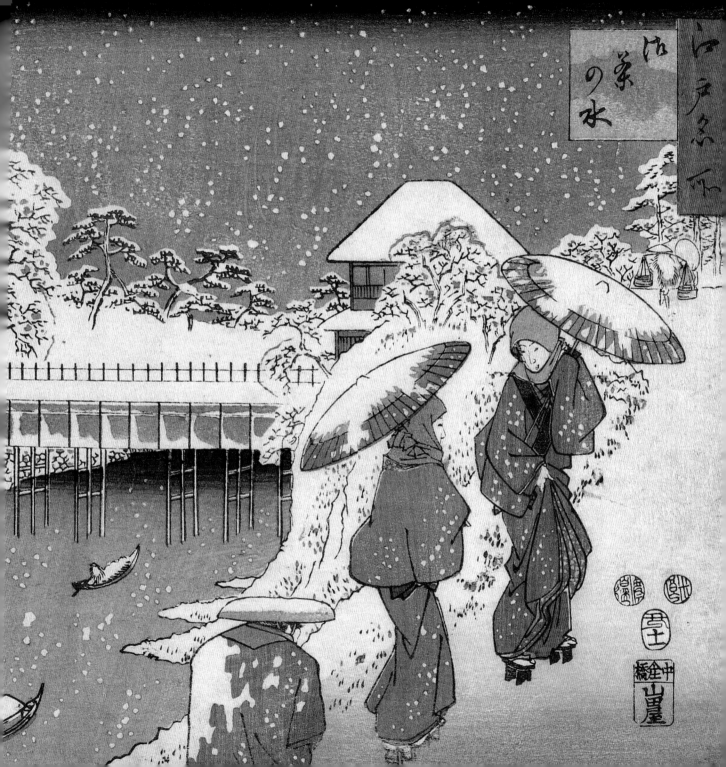

ABOVE Festivals such as Girls' Day still exert a cultural fascination. Ca. 1772–1775, Utagawa Toyoharu, *The Third Month: The Doll Festival, Gathering Shellfish at Low Tide,* from the series *Day and Night Scenes of the Twelve Months.*

ABOUT THIS BOOK

This book offers a vivid glimpse into the lifestyle of the Japanese in the nineteenth and early twentieth centuries, and particularly into a burgeoning love of travel, through the predominant visual media of the time, woodblock prints. The prints featured here are not only classical *ukiyo-e* (literally 'pictures of the floating world," a term used to describe the hedonistic world of entertainment often depicted in these prints) from the late seventeenth to the nineteenth centuries, but also include examples of *shin hanga*, literally "new prints," created in the early twentieth century, which offer a look at Japan that is somewhat closer to the present day.

As well as famous sights in the cities of Tokyo, Kyoto, and Osaka, and other scenic locations that are as popular with travelers today as they were in the past, such as Hakone, Nikko, and Nara, this book also depicts the cultural icons broadly identified with a traditional Japanese lifestyle. Sumo, kabuki, hot springs, blossom viewing, kimono, tea-drinking, and geisha all exerted the same fascination over travelers in the nineteenth century as they do today.

Because the nineteenth century heyday of woodblock print production in Japan coincided with the country's Westernization, frequent themes to be found in this book are the Western fashions and modes of transport that suddenly appeared in Japan from the 1860s onwards. The advent of the railway in particular provided much inspiration for woodblock print artists of the day.

The bulk of the prints in this book are famous and popular images, for instance from the previously mentioned

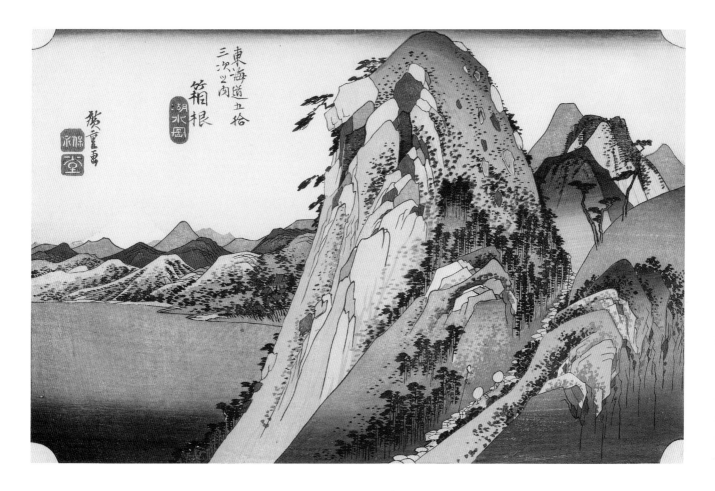

celebrated series by Hiroshige and Hokusai. A few of the prints are rather rare, such as Utagawa Kuniyoshi's *Fuji from Mimeguri* (see page 115). Prints like this one were meant to be used as fans and therefore not many have survived. All prints in this book are of the original artworks, created at the time indicated in the captions. Some prints are cropped to emphasize details. When prints are cropped radically, the caption includes the word "detail" and a thumbnail of

ABOVE Hakone, near Lake Akinosho, was one of two checkpoints along the Tokaido, Japan's most frequented road. These checkpoints controlled the flow of weapons into Edo and the movement of feudal lords and their families out of Edo. Ca. 1832–1833, Utagawa Hiroshige, *Hakone: Picture of the Lake*, from the series *The Fifty-three Stations along the Tokaido*.

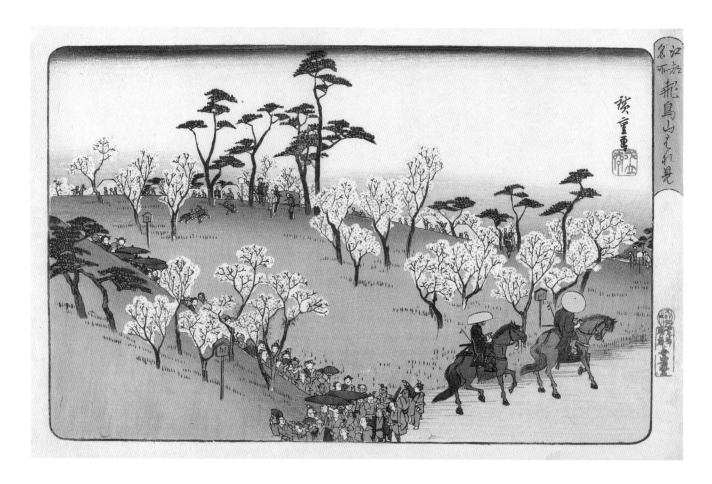

the uncropped print can be seen on page 166. Most of the prints are from the remarkable collections at the Minneapolis Institute of Arts and the Honolulu Museum of Art; the rest are from the collections of the British Museum, National Diet Library, Library of Congress, Scripps College, Paulette and Jack Lantz, Scholten Japanese Art, THEARTOFJAPAN. COM, and le cabinet japonais / Kotobuki GmbH. I am grateful for the generosity of these institutions and individuals in granting permission to reproduce their prints in this book.

ABOVE In 1720, the shogun Tokugawa Yoshimune ordered the planting of cherry trees in Asukayama for the enjoyment of the people. This area is now Asukayama Park in Tokyo's Kita Ward. Ca. 1832–34, Utagawa Hiroshige, *Cherry-blossom Viewing at Asukayama*, from the series *Famous Places in Edo*.

BELOW On top of this mountain is a shrine dedicated to Akiba Gongen, a deity that controls fire. Ca. 1837, Utagawa Hiroshige. *Mount Akiba in Totomi Province,* from the series *Famous Places of Our Country.*

OVERLEAF Today's Shinagawa Station used to be Takanawa Station until 1924 when it was renamed. 1872, Ikkei, *The Steam Train at Tokyo Takanawa.*

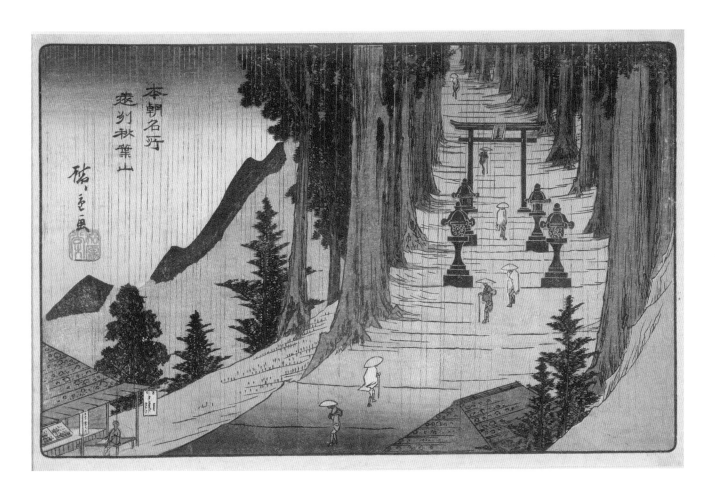

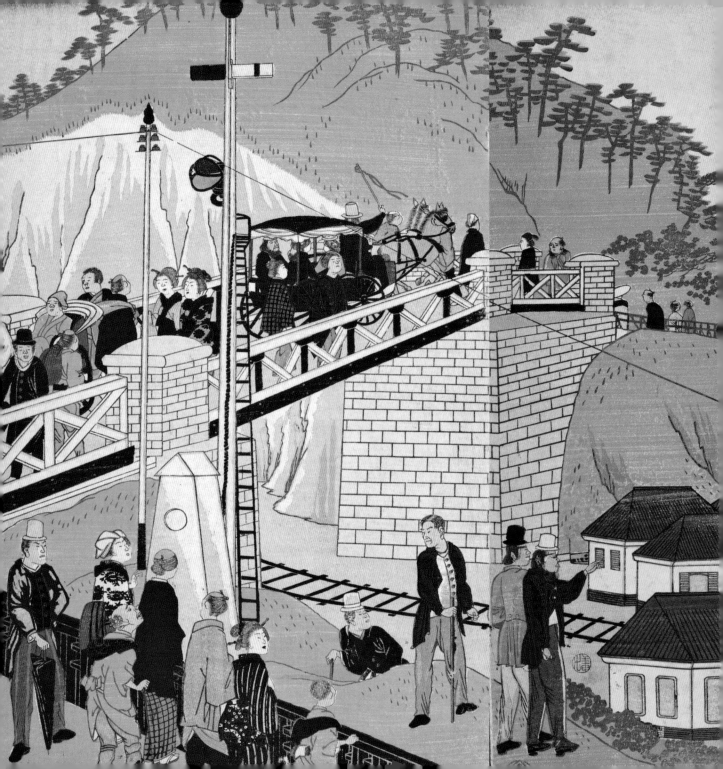

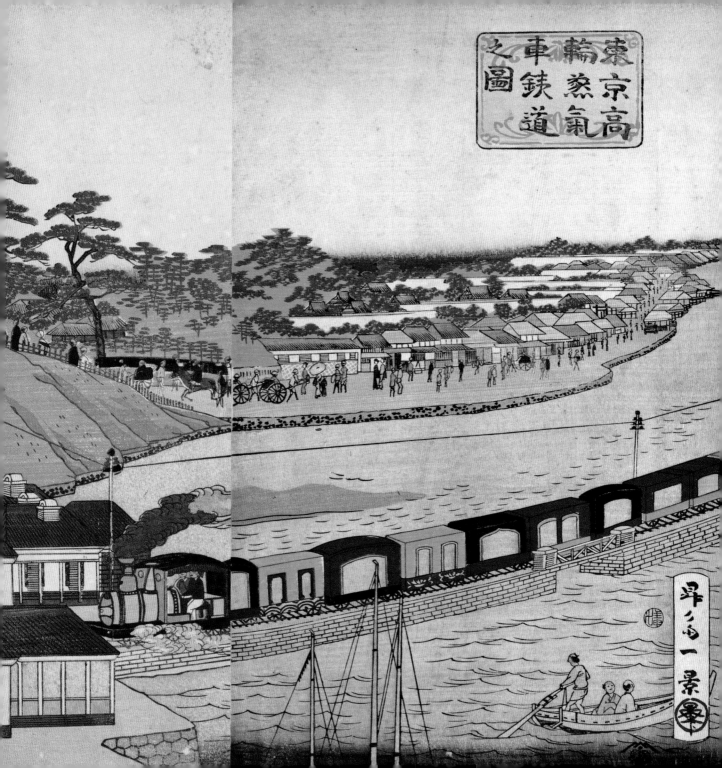

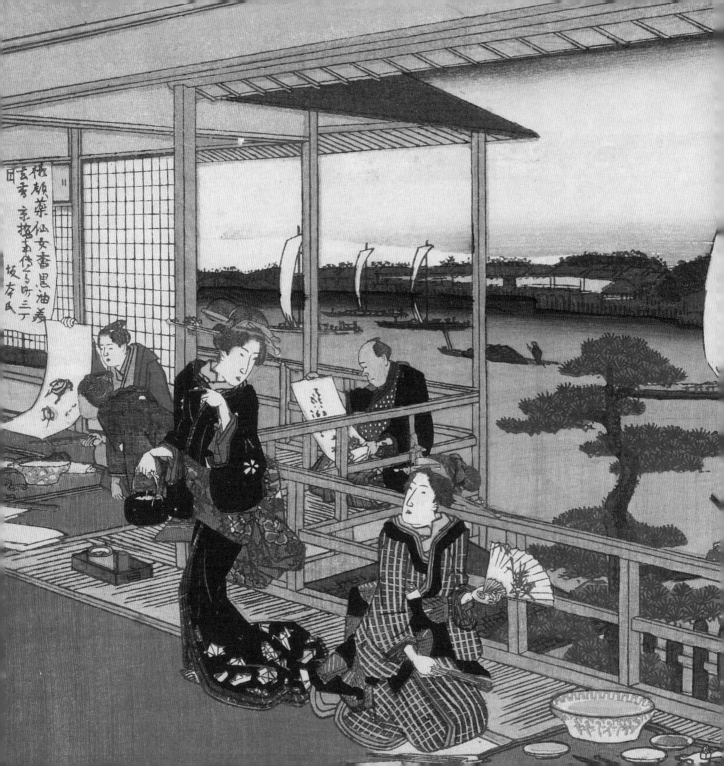

Sights of Tokyo

Edo, originally a small fishing town, became the residence of the Tokugawa shogunate in 1603 and remained so until 1868, an era that is known as the Edo period. By the mid-eighteenth century Edo's population had topped the one-million mark, making it one of the largest cities in the world. In 1868, Edo was renamed Tokyo—meaning "Eastern capital," and today retains its status as one of the planet's most populated residential areas.

NIHONBASHI

Nihonbashi, which literally means "Japan Bridge," was the starting point of all highways that left Edo. It was therefore considered not just the heart of the city but also the heart of Japan. Said to have been originally built in 1603, the bridge that stands today was reconstructed in 1911 and now lies in the shadow of an overhead expressway, which detracts somewhat from any feelings of nostalgia when visiting.

The Nihonbashi area was Edo's bustling center for commerce and culture. In 1683, this was where the Mitsui family established their kimono store Echigoya, which eventually became the department store Mitsukoshi. This district is today the financial center of Tokyo, home to the Bank of Japan headquarters and the Tokyo Stock Exchange.

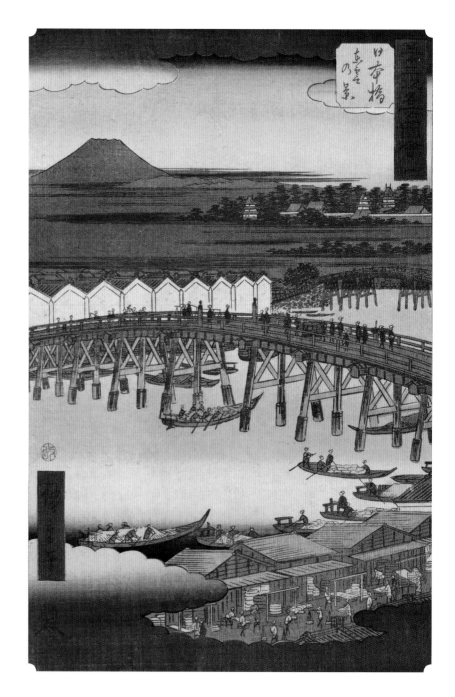

PAGE 20 This restaurant was known as a venue for literati and art gatherings. It provided a great view of the Sumida River from its second floor. Ca. 1838–1840, Utagawa Hiroshige, *Kawachiya at Yanagi Bridge in Ryogoku* (detail), from the series *Collection of Famous Restaurants in Edo*.

PAGE 21 1926, Takahashi Hiroaki, *Asakusa Kannon Temple, Tokyo*.

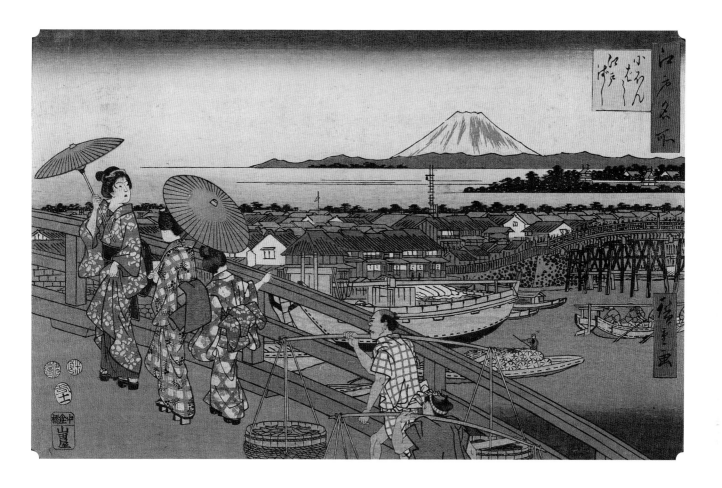

FACING PAGE A lively scene showing merchants and strollers. 1855, Utagawa Hiroshige, *No 1*, *Nihon Bridge: View of Dawn Clouds*, from the series *Famous Sights along the Fifty-three stations.*

ABOVE Looking westward from Edobashi Bridge with Nihonbashi Bridge in the background and Mount Fuji in the far distance. 1853, Utagawa Hiroshige, **Nihonbashi Bridge from Edobashi Bridge**, from the series **Famous Places in Edo.**

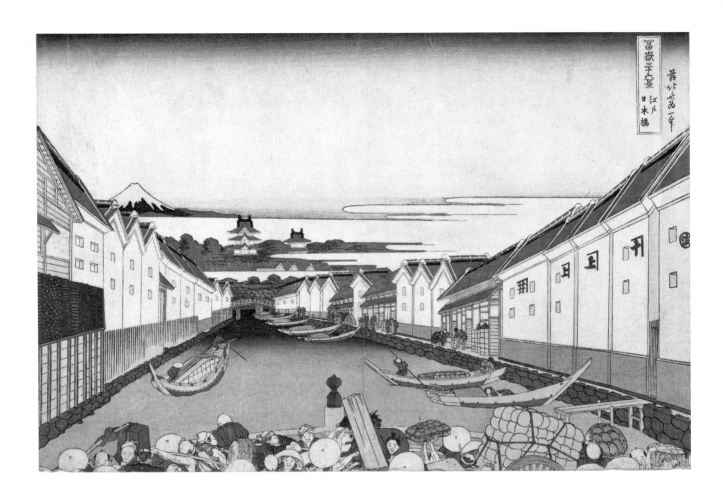

ABOVE The view from Nihonbashi
Bridge toward Edo Castle, with white-
walled warehouses lined along the blue
waterway. Ca. 1830–1831, Katsushika
Hokusai, *Nihonbashi Bridge in Edo*,
from the series *Thirty-six Views of
Mount Fuji*.

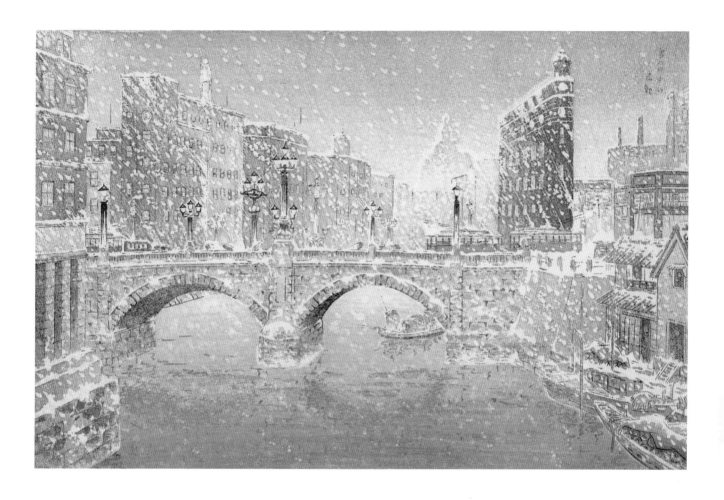

ABOVE Trolley cars cross the modern stone version of the Nihonbashi Bridge with its massive neoclassical iron street lights. 1930, Bannai Kokan, *Snow at Nihonbashi Bridge*, from the series *Fifty-three Stations of a Modern Tokaido.*

ASAKUSA

Asakusa is home to Sensoji Temple (also referred to as Kinryuzan Temple, Kinryuzan Kannon Temple, or the Kannon Temple), the oldest Buddhist temple in Tokyo, founded in the year 645 and dedicated to the bodhisattva Kannon. Since 941 its entrance has been dominated by the Kaminarimon—the Thunder Gate—featuring a massive paper lantern painted in red and black.

In the Edo period, Asakusa was an entertainment district. Just a fifteen-minute walk from Sensoji Temple were the pleasure quarters of Yoshiwara, established by the government in the mid-seventeenth century to contain prostitution. Today, with its high concentration of relatively old houses and traditional businesses and festivals, including the Sanja Matsuri, one of the largest festivals in Japan, Asakusa draws many tourists wishing to experience "old Japan."

RIGHT On the left of the print is the Main Hall of Sensoji Temple. This structure was destroyed during the Second World War and rebuilt in 1964 in ferroconcrete. 1830s, Keisai Eisen, *Picture of the Grounds of the Kinryuzan Kannon Temple in Asakusa, Edo.*

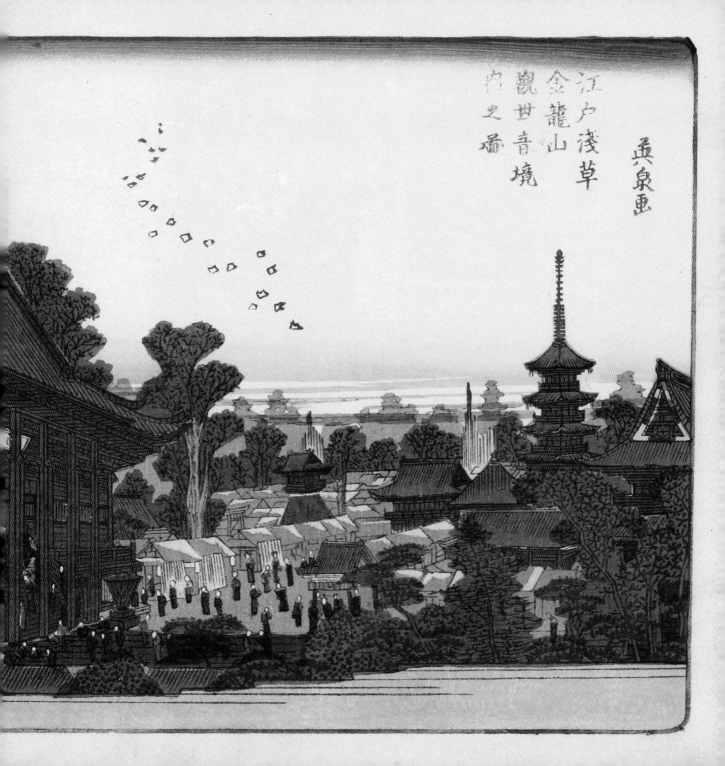

江戸浅草
金龍山
観世音境
内之図

英泉画

RIGHT The Nio Gate of Sensoji Temple is flanked on either side by two imposing guardian deities. Like the Main Hall, which is directly behind it, the gate was rebuilt in 1964 after being destroyed in the Second World War. Ca. 1815, Utagawa Kuniyasu, *Perspective Picture of the Nio Gate of Asakusa in Edo.*

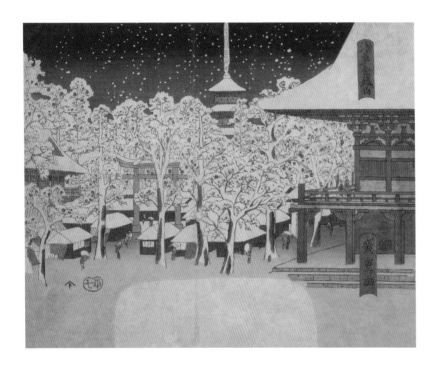

ABOVE 1852, Utagawa Hiroshige, *Kinryuzan Temple at Asakusa.*

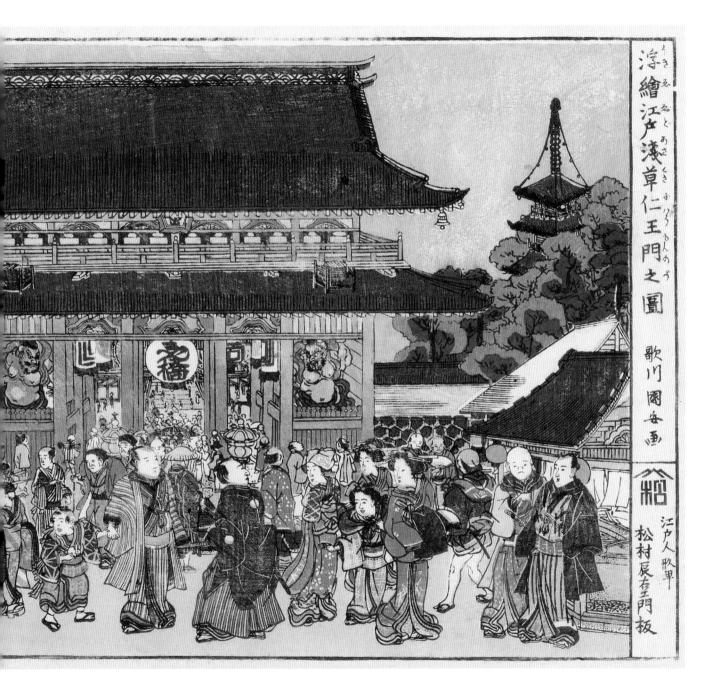

浮繪江戸淺草仁王門之圖

歌川國盛画

江戸人形甲

松村辰左衞門板

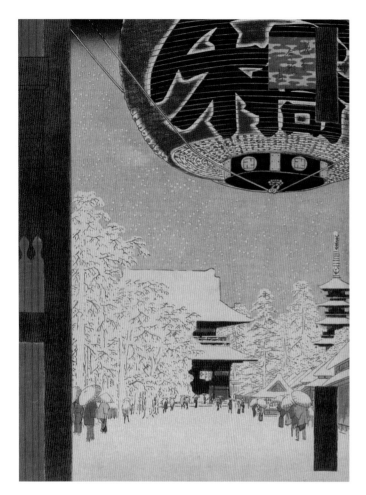

FACING PAGE Visitors climb
the stairs to the Main Hall of
Sensoji Temple, in front of which
hangs a paper lantern similar
to the one at Kaminarimon gate.
1934, Kasamatsu Shiro, *The Great
Lantern of the Kannon Temple,
Asakusa* (detail).

ABOVE View of the entrance to
Sensoji Temple from Kaminarimon
gate. The pagoda on the left was
rebuilt in 1964 and is today on the
right. 1856, Utagawa Hiroshige,
Kinryuzan Temple in Asakusa
(detail), from the series *One
Hundred Famous Views of Edo.*

RIGHT Asakusa's Torigoe Shrine
is the location of a famous festival
that takes place every year in
June featuring a procession with
a portable shrine *(mikoshi)* that
weighs almost four tons. 1934,
Kasamatsu Shiro, *Spring Snow—
The Torigoe Shrine at Asakusa.*

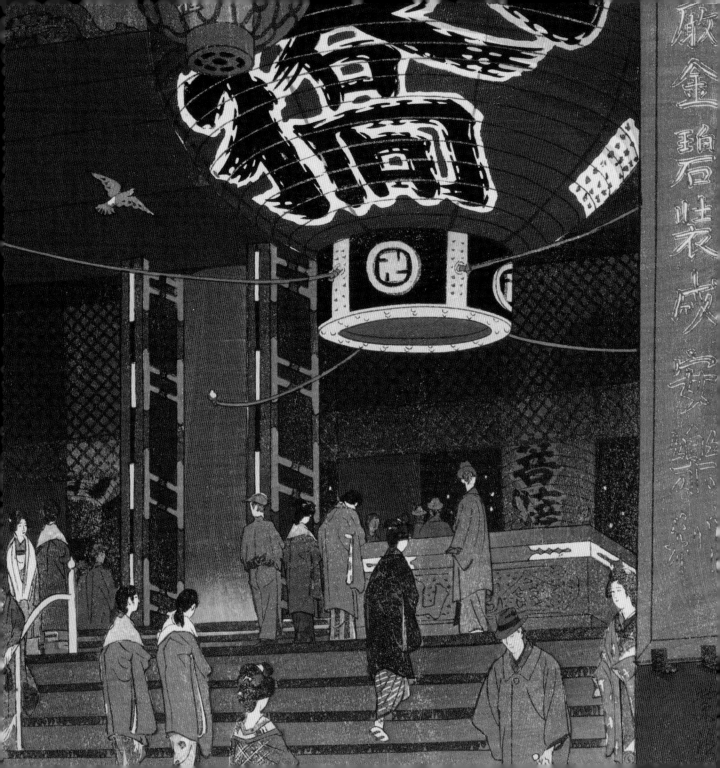

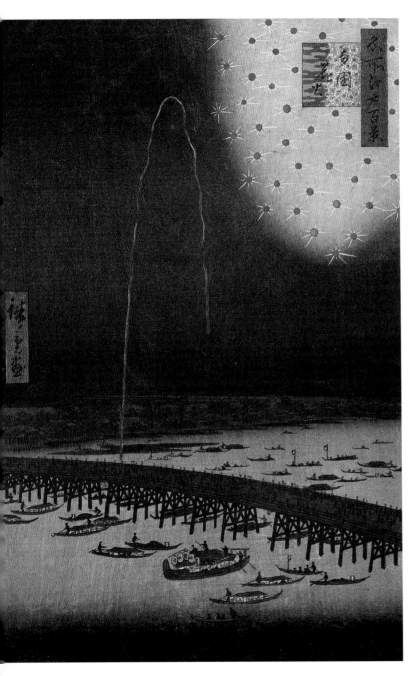

THE SUMIDA RIVER AND RYOGOKU

The fourteen-mile-long Sumida River flows through Tokyo into Tokyo Bay as one of the lower branches of the Arakawa River. The name Sumida first appears in 835, but the river went by several other names until the turn of the nineteenth century, when the name Sumida River was made official.

Several bridges span the Sumida, one of the oldest of which is the Ryogoku Bridge, dating from the mid-seventeenth century. Every summer the river hosts one of the oldest and most famous fireworks displays in Japan.

LEFT The Ryogoku Bridge was first called Ohashi Bridge but was renamed in 1694. After parts of it collapsed from the weight of the crowds during the fireworks of August 10, 1897, it was rebuilt in steel. 1858, Utagawa Hiroshige, *Fireworks at Ryogoku*, from the series *One Hundred Famous Views of Edo.*

BELOW The road in the foreground leads to the Suijin Shrine, renamed the Sumida River Shrine in 1872. In the background Mount Tsukuba rises through the clouds. 1856, Utagawa Hiroshige, *Suijin Shrine and Massaki on the Sumida River*.

ABOVE Erected in 1630, the Willow Bridge crosses the Kanda River near its convergence with the Sumida River. 1927, Ohara Shoson, *Snow on Willow Bridge*.

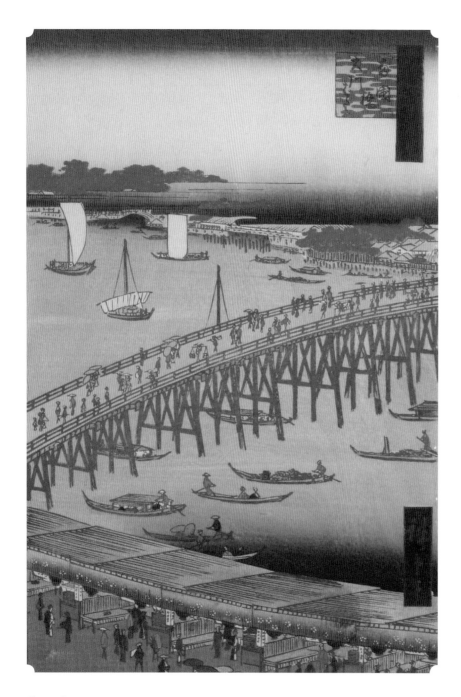

LEFT The row of teahouses along the banks of the Sumida River made this one of the liveliest places in Edo, especially in summer. 1856, Utagawa Hiroshige, *Ryogoku Bridge and the Great Riverbank,* from the series *One Hundred Famous Views of Edo.*

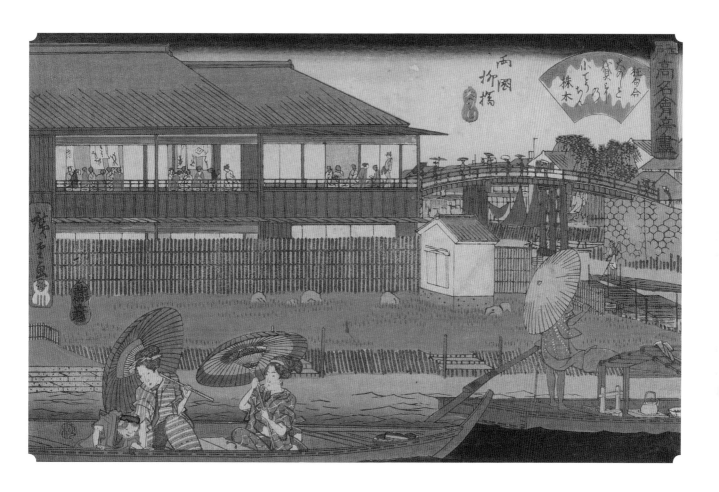

ABOVE The Onoshi was a popular location for calligraphy and painting meetings. Ca. 1838–1840, Utagawa Hiroshige, **Onoshi at Yanagi Bridge in Ryogoku,** from the series *Collection of Famous Restaurants in Edo.*

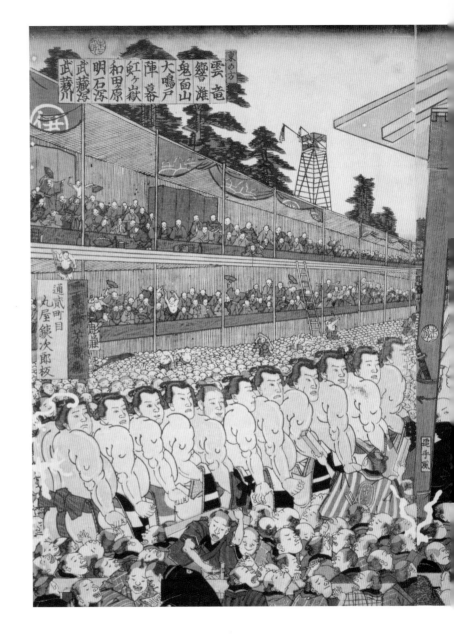

RIGHT Ryogoku has been the site of Tokyo's sumo hall only since 1909, but sumo is said to have started over 2,000 years ago. 1859, Utagawa Yoshiiku, *Picture of the Entrance Procession for a Grand Fundraising Sumo Tournament.*

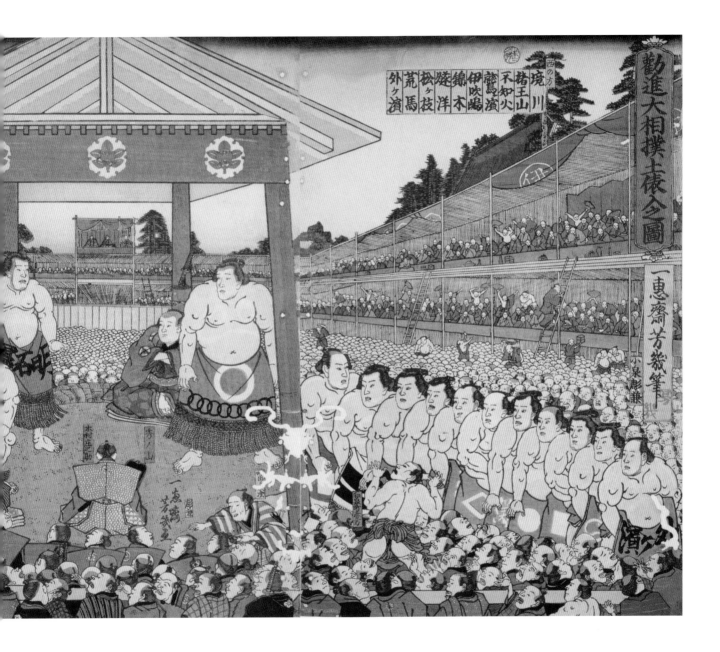

TOKYO IMPERIAL PALACE

The current palace is located on the grounds of the old Edo Castle, and is where the Japanese emperor and his family live today. The inner palace is off limits to the general public but the surrounding paths and parks provide a welcome oasis in a city that is short of greenery. Visitors can enjoy strolling around the three-mile perimeter of the moat and relaxing in the tranquility of the East Garden.

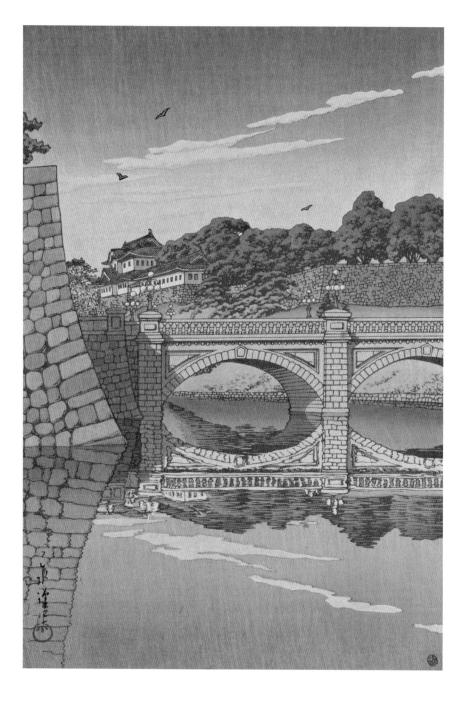

RIGHT This stone bridge leads into the palace and was built in 1887 in place of the wooden bridge that had been an access point to the old Edo Castle. 1930, Kawase Hasui, *Morning at Niju Bridge.*

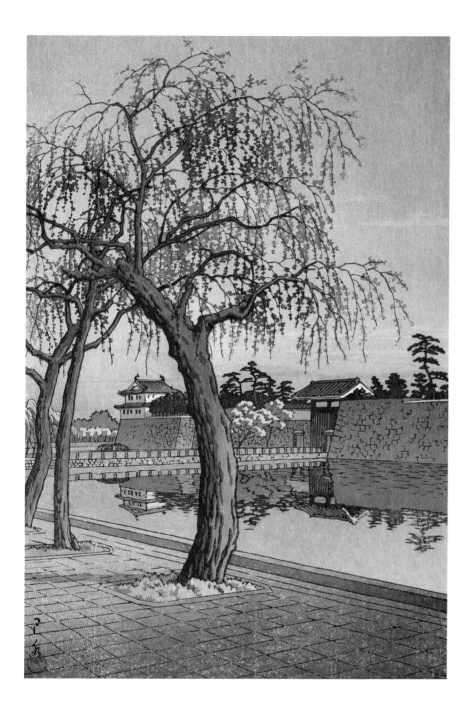

LEFT This gate leads into the East Garden, part of the Imperial Palace that is accessible to the public. 1952, Kawase Hasui, *Springtime Evening, Ote Gate.*

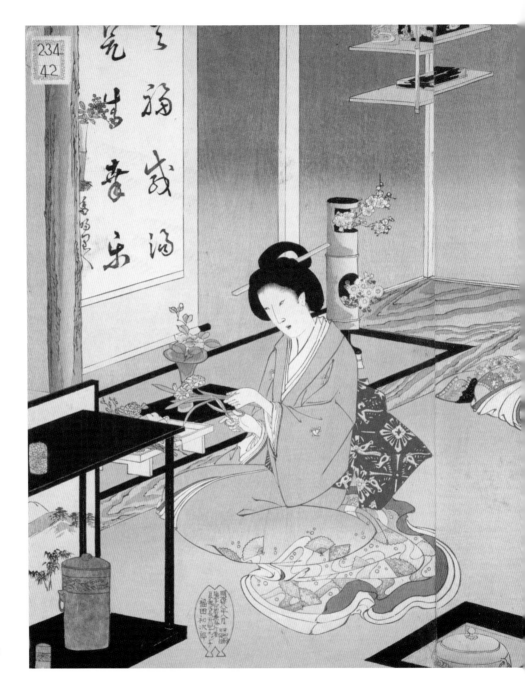

RIGHT Four women are carefully observing a fifth woman preparing a flower arrangement in the *tokonoma*, an alcove designed for the display of hanging scrolls and flowers. 1895, Toyohara Chikanobu, **Tea Ceremony with Flower Arranging in Turn**, from the series **Chiyoda Inner Palace**.

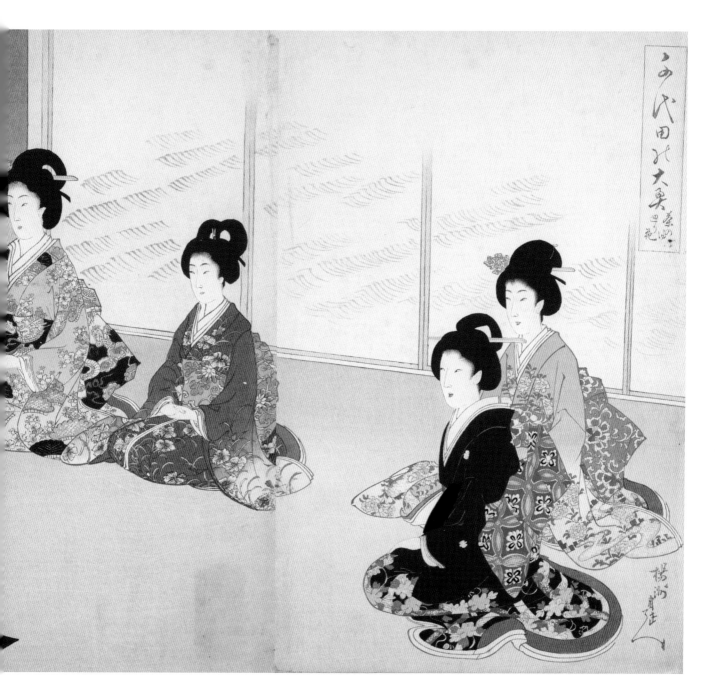

THE FLOATING WORLD

The term "floating world" described the hedonistic world of entertainment during the Edo period. Floating-world culture was closely associated with Yoshiwara, the district set up by the Japanese authorities in the seventeenth century to contain the sex trade. Streets populated with courtesans and geisha in their colorful finery provided inspiration for many woodblock artists. Yoshiwara was a flourishing district for commerce of all sorts until prostitution was made illegal in 1958, and the area went into decline. In present-day Tokyo this neighborhood roughly corresponds to the area known as Senzoku Yonchome.

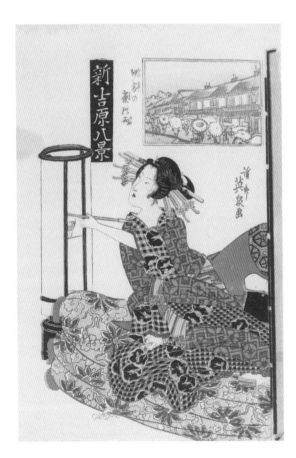

LEFT Ca. 1821–1822, Keisai Eisen, *Night Rain with a Regular Customer*, from the series *Eight Views in the New Yoshiwara*.

RIGHT Nakanocho was the main business road in Yoshiwara, and it was a popular pastime to enjoy the cherry blossoms lining the road in front of the brothels. Ca. 1834–1835, Utagawa Hiroshige, *Cherry Blossoms at Night on Naka-no-cho in the Yoshiwara*, from the series *Famous Places in the Eastern Capital*.

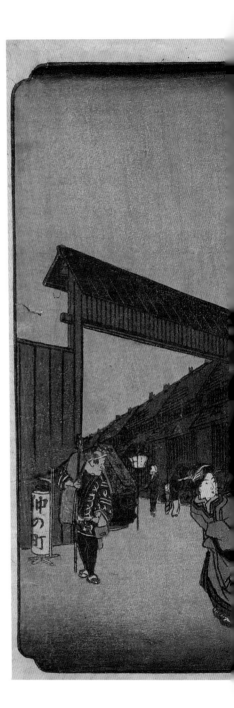

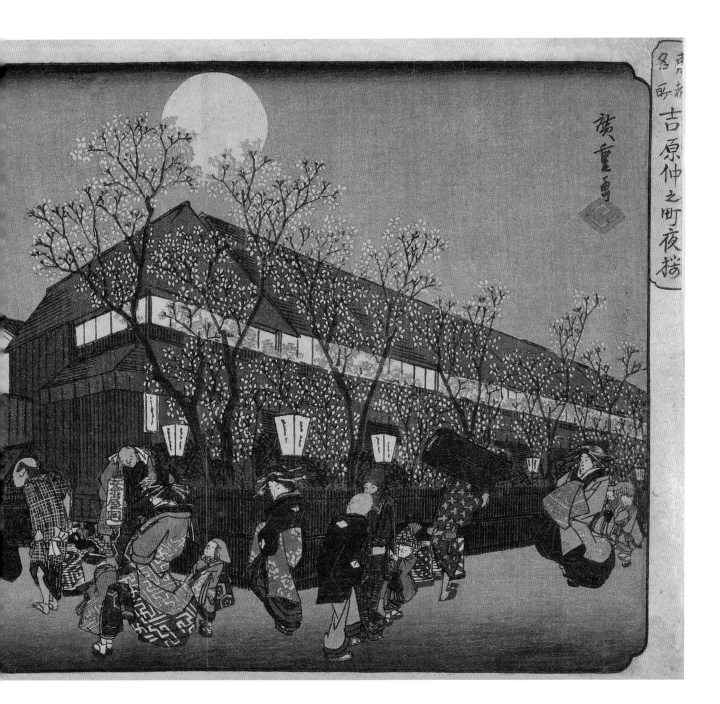

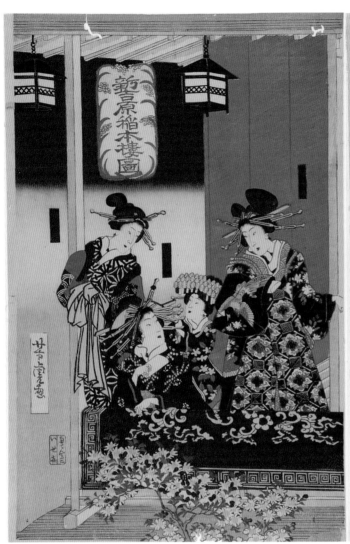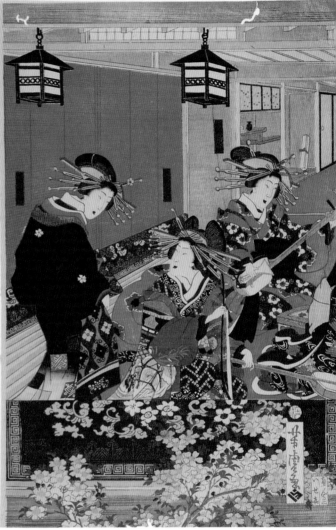

ABOVE A group of famous courtesans, dressed in elaborate kimono, are preparing their instruments to make some music for guests. 1870, Utagawa Yoshitora, *View of the Inamoto House in the New Yoshiwara*.

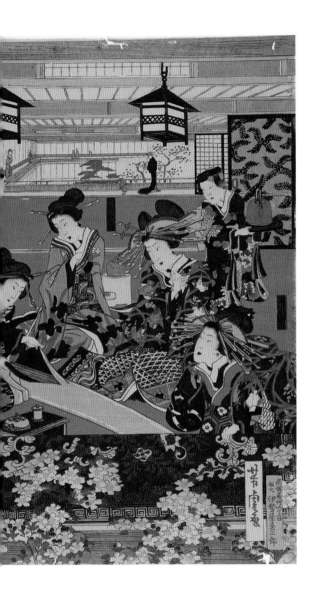

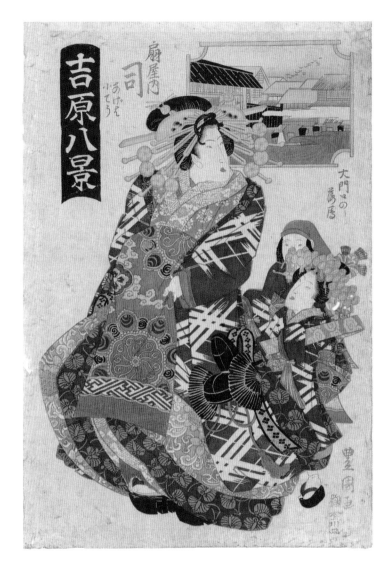

ABOVE Late 1820s, Utagawa Toyokuni II,
***Descending Geese at the Great Gate
Juxtaposed to Tsuakasa of the Ogiya and Her
Attendants Ageha and Kocho*** from the series
Eight Views of the Yoshiwara.

EDO-ERA DINING

The Japanese obsession with food and restaurants was as strong in the nineteenth century as it is today. Utagawa Hiroshige's print series *Collection of Famous Restaurants in Edo* gives us a glimpse into restaurant culture of the time, showing that many traditions survive to this day, such as sitting on the floor rather than on chairs, and eating from a variety of beautifully decorated dishes served on low tables.

BELOW The Manpachi in present-day Akihabara was famous for its many rooms that guests could hire for special purposes. Ca. 1838–1840, Utagawa Hiroshige, *Night View of Yanagi Bridge at the Manpachi Restaurant,* from the series *Collection of Famous Restaurants in Edo.*

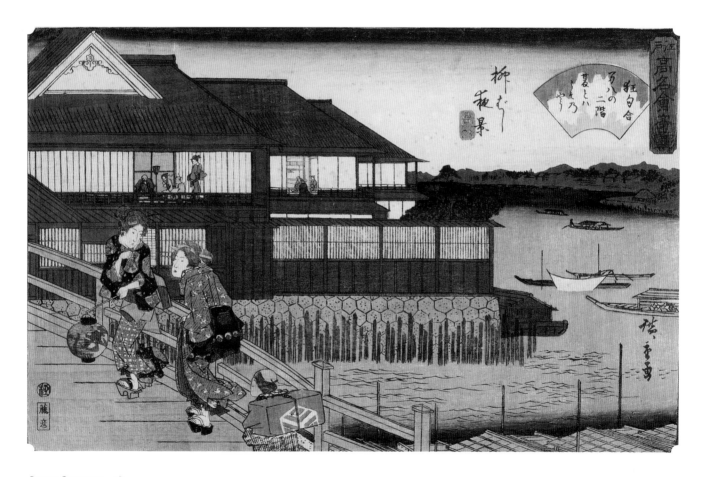

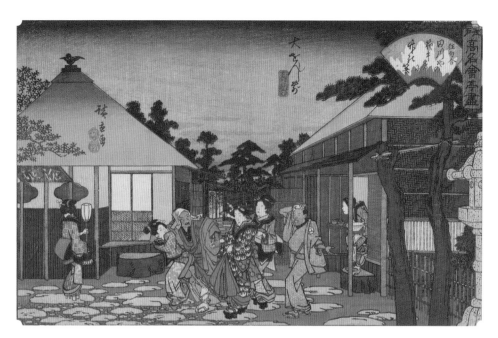

TOP An intoxicated man and his friend are leaving the Tagawaya accompanied by lower-ranked courtesans. Ca. 1838–1840 Utagawa Hiroshige, *Tagawaya Restaurant in front of Daion Temple*, from the series *Collection of Famous Restaurants in Edo.*

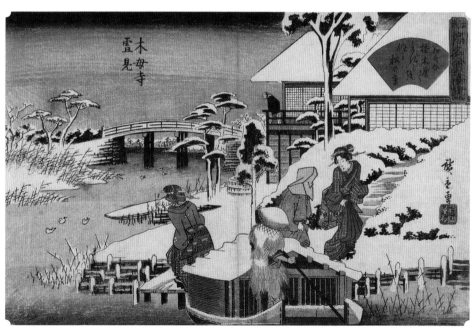

BOTTOM The Uekiya Restaurant was famous for its taro roots and clams as well as for its vicinity to the Yoshiwara entertainment district. Ca. 1838–1840, Utagawa Hiroshige, *Uekiya Restaurant and Snow Viewing at Mokubo Temple*, from the series *Collection of Famous Restaurants in Edo.*

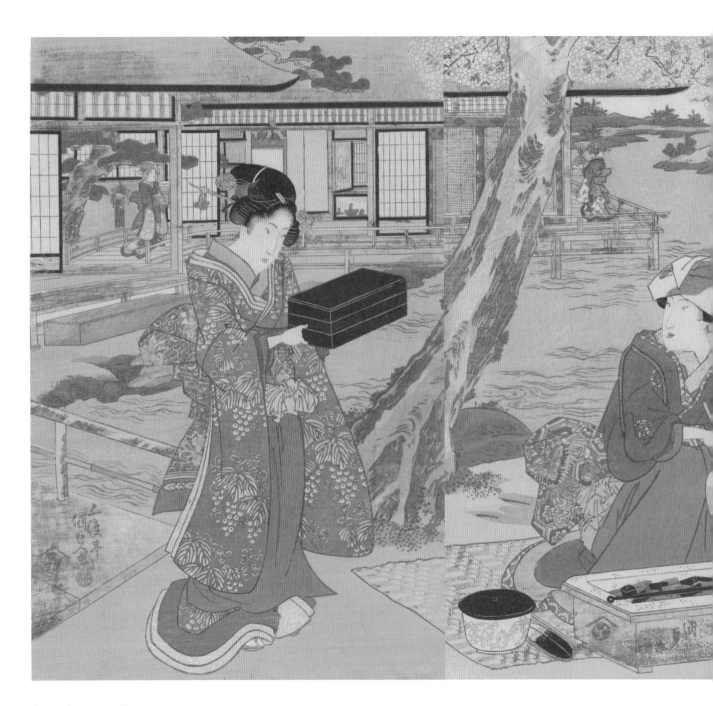

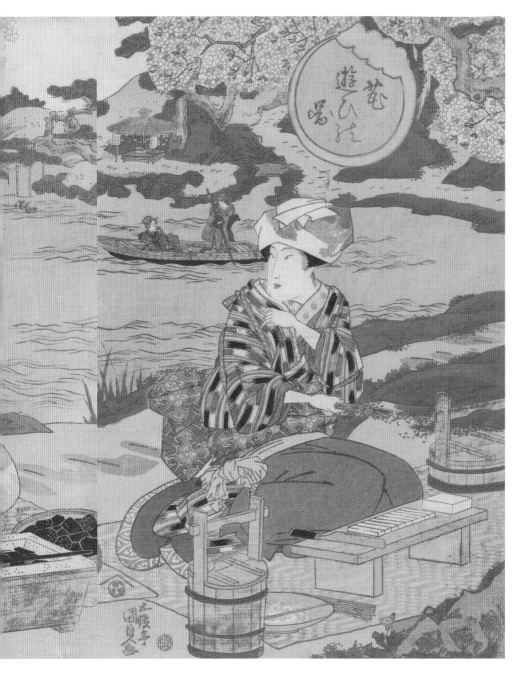

LEFT Three beauties prepare a picnic under a blossoming cherry tree. The woman on the right is cutting what appears to be mochi rice cake and the one in the center is watching the charcoals where they will be grilled. 1820s, Utagawa Kunisada, *Picture of Entertainment under Cherry Blossoms.*

THE GINZA

During the Edo period, the government agency in charge of mining silver coins was located here, hence the name Ginza, which literally means "Silver Place." After a devastating fire in 1872, Western-style brick buildings were erected and this area was designated a "model of modernization," ultimately transforming into the epitome of urban style and sophistication. As such, Ginza began to gain popularity as a subject for woodblock print artists from the 1870s onward.

LEFT Ginza bustles with nighttime entertainment seekers. The large lantern in the center carries an advertisement reading *azuma odori* (dance of the eastern capital). 1934, Kasamatsu Shiro, ***The Ginza on a Spring Night***.

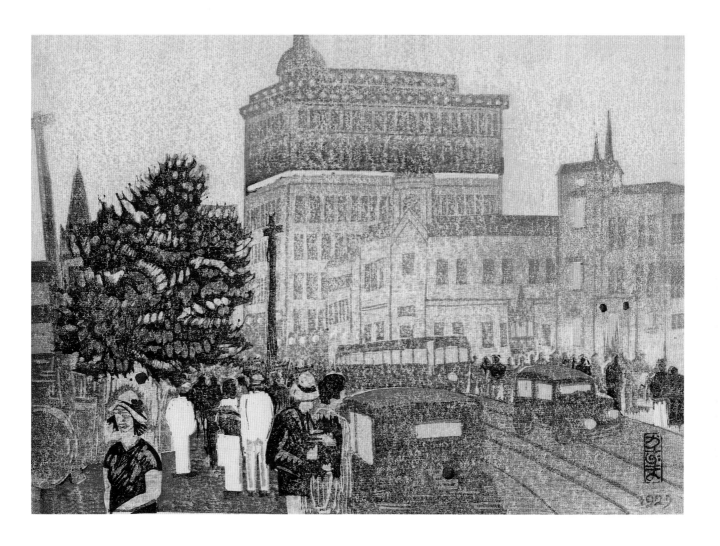

ABOVE Streetcars like the one depicted here operated in Ginza from the 1910s until 1967 when the lines were torn out. 1929, Oda Kazuma, *Ginza by Night.*

The signboard identifies
this Ginza store, whose shelves are
crammed with bottles and cans,
as a producer and seller of
domestic fruit. 1882, Inoue Yasuji,
Night View of a Ginza Store.

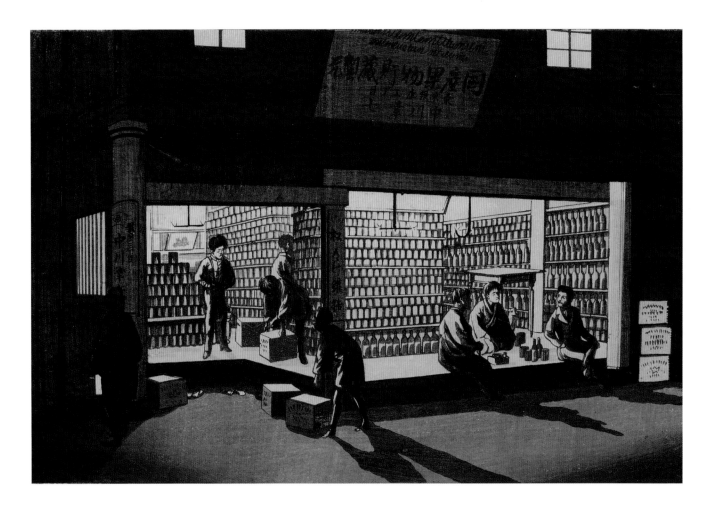

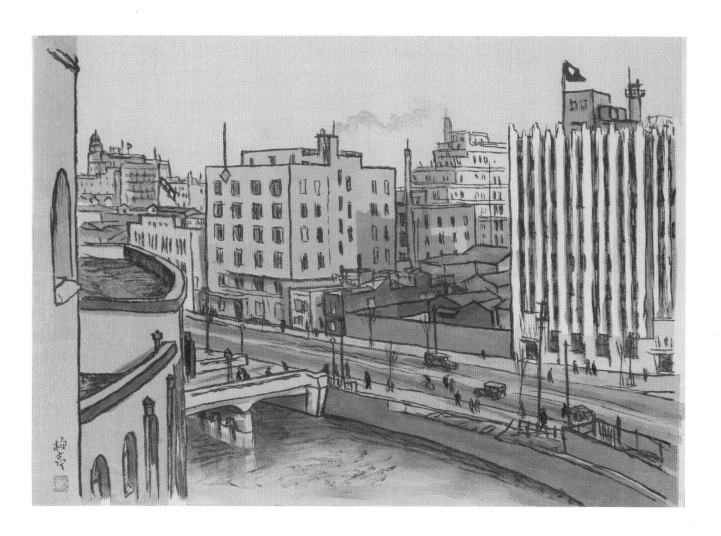

ABOVE The building on the right
could be the Matsuda Building which
later became the Toshiba Building. Ca.
1925, Ishii Hakutei, *Ginza*.

TOKYO STATION

Tokyo Station was built in 1914 during a period of rapid Westernization for Japan, evidenced not only by the development of a rail network but by the increasing number of buildings with a European architectural style. Today the area around this iconic edifice has been through another wave of modernization, and the station terminal is surrounded by glass tower blocks containing fashionable malls and hotels.

BELOW 1928, Ishii Tsuruzo, *Evening View of Tokyo Station.*

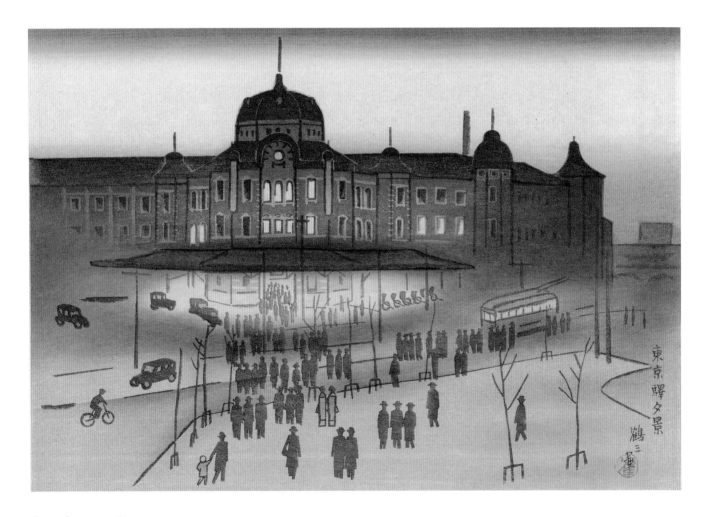

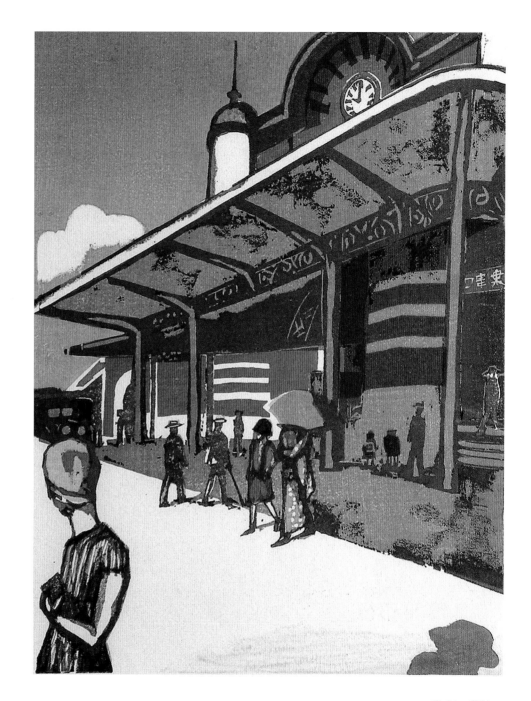

RIGHT 1946, Onchi Koshiro,
Tokyo Station, from the series
Scenes of Lost Tokyo.

SHOPS AND TRADES

In the seventeenth century, cities like Edo and Osaka developed specific areas that were related to a certain trade. Nihonbashi, for example, became known as a center for commerce and was home to shops like the dry goods company Shirokiya which opened in 1662. In an age when all dwellings were built of wood, lumber was one of Edo's most important commodities and lumberyards were a not-uncommon subject for woodblock prints.

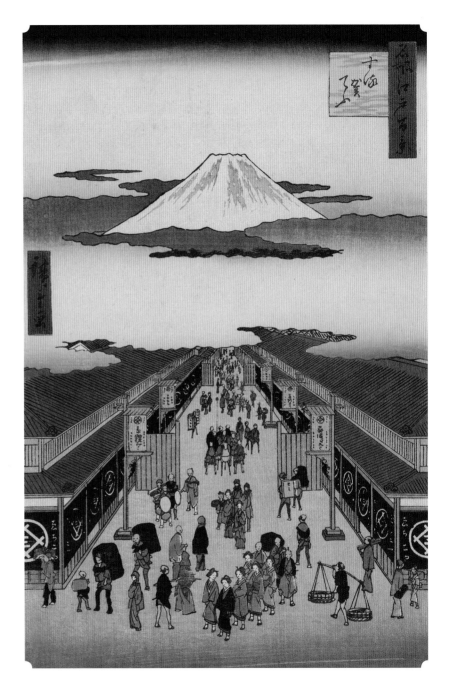

RIGHT The road is flanked by stores belonging to Mitsui Echigoya, a successful textile business and money broker. The store on the left became the Mitsukoshi Department Store and the one on the right Mitsui Bank. 1856, Utagawa Hiroshige, *Suruga-cho, from the series* **One Hundred Famous Views of Edo.**

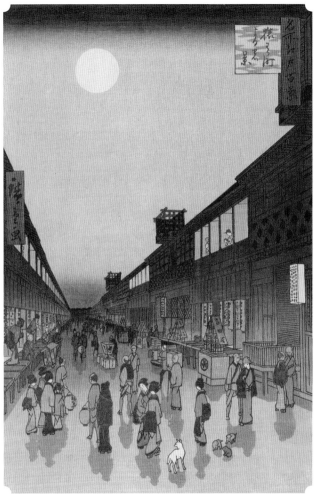

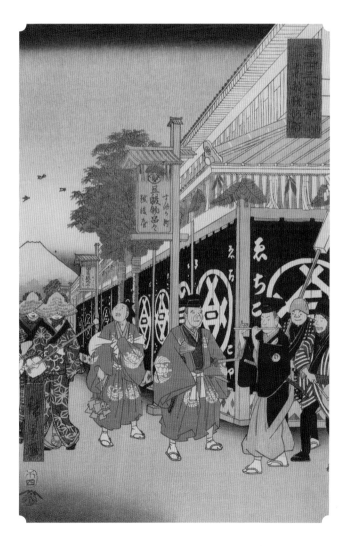

BELOW Manzai dancers, traditionally part of New Year's festivities, are passing the Mitsukoshi dry goods store. 1858, Utagawa Hiroshige, *The Suruga District in Edo,* from the series *Thirty-six Views of Mount Fuji.*

ABOVE After a fire in 1841 the government ordered all Edo kabuki and puppet theaters to relocate to the district of Saruwaka were they remained until the early Meiji period. 1856, Utagawa Hiroshige, *Night View of Saruwaka-machi,* from the series *One Hundred Famous Views of Edo.*

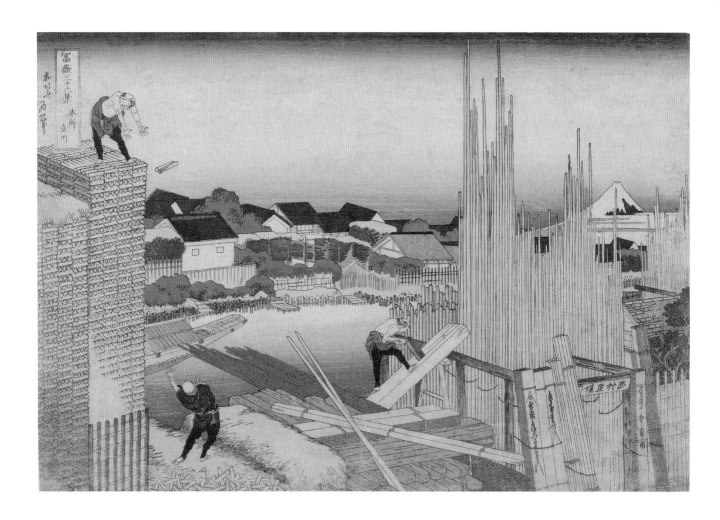

ABOVE This is one of several lumberyards on the riverbank of Edo's Honjo district. Ca. 1830–1831, Katsushika Hokusai, *Tatekawa in Honjo*, from the series *Thirty-six Views of Mount Fuji.*

BELOW In 1701, an area in Edo's Fukagawa became the city's official lumberyard as it was surrounded by waterways that protected from fire and allowed easy transport. 1856, Utagawa Hiroshige, *Fukagawa Lumberyards*, from the series *One Hundred Famous Views of Edo.*

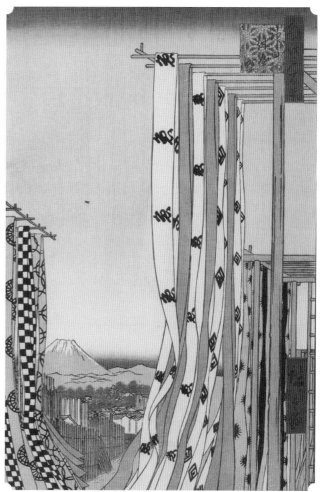

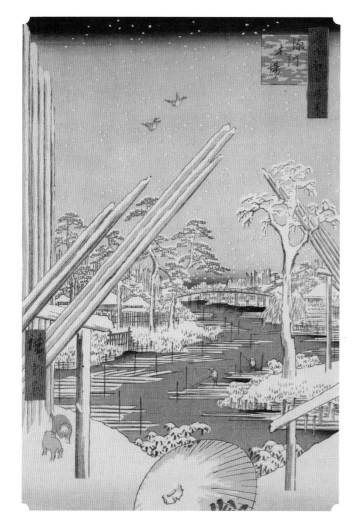

ABOVE Fabric freshly dyed in traditional shades of blue hangs out to dry. Ca. 1857, Utagawa Hiroshige, *Dyers' Quarter, Kanda*, from the series *One Hundred Famous Views of Edo.*

OCHANOMIZU AND THE KANDA RIVER

The central Tokyo district of Ochanomizu was near the living quarters of samurai lords. The name, which literally means "water for tea" derives from a visit by the shogun Tokugawa Hidetada (1597–1632) who is said to have enjoyed a cup of tea here made from local well water. The Kanda River, which passes through Ochanomizu, is a frequent motif in woodblock prints.

BELOW On the right is Shoheizaka Gakumonjo, the Confucian school for officials, now the site of Tokyo Medical and Dental University. 1820s (original edition ca. 1804–1818), Shotei Hokuji, *View of Ochanomizu.*

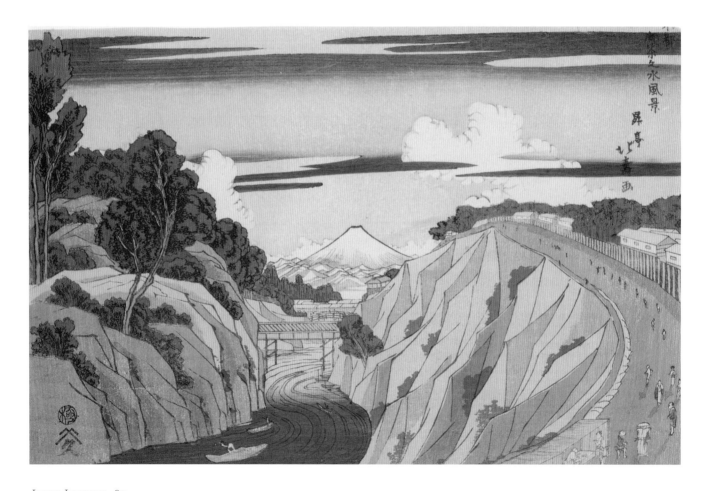

BELOW A boat on the Kanda River at night carries guests enjoying the lights of the fireflies. This location is near Suidobashi Bridge. 1880, Kobayashi Kiyochika, *Fireflies at Ochanomizu* (detail).

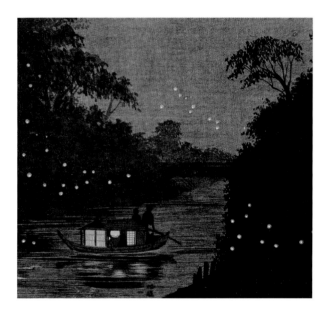

RIGHT Ochiai is in the present-day Shinjuku ward of Tokyo and is where the Kanda River meets the Myoshoji River. Famous for its clean water, this was a major site for fireflies and became a popular location for textile production. 1864, Utagawa Kunisada, *Fireflies at Ochiai*, from the series *The Pride of Edo: Thirty-six Scenes.*

TEMPLES AND SHRINES

The Shiba area of Tokyo, near Tokyo Tower, is off the beaten track for twenty-first century tourists, but in the Edo period its temples were popular places of worship. A must-see since the Edo period is Kameido Tenjin Shrine in the east of the city, famous for its wisteria blossoms in spring. One of the most famous modern day Tokyo sights is Meiji Shrine, built in 1921, after the heyday of the woodblock print. It can be found, however, depicted in the *shin hanga* (lit. "new prints") that became popular from the start of the twentieth century.

RIGHT The Daradara Matsuri at Shiba Daijingu Shrine (previously known as the Shinmei Shrine) is still held every September. It is also known as the Ginger Festival, with many stalls selling the eponymous spice. Ca. 1835–1842, Keisai Eisen, *View of the Ginger Market at the Shiba Shinmei Shrine Festival*, from the series *Collection of Famous Places in the Eastern Capital*.

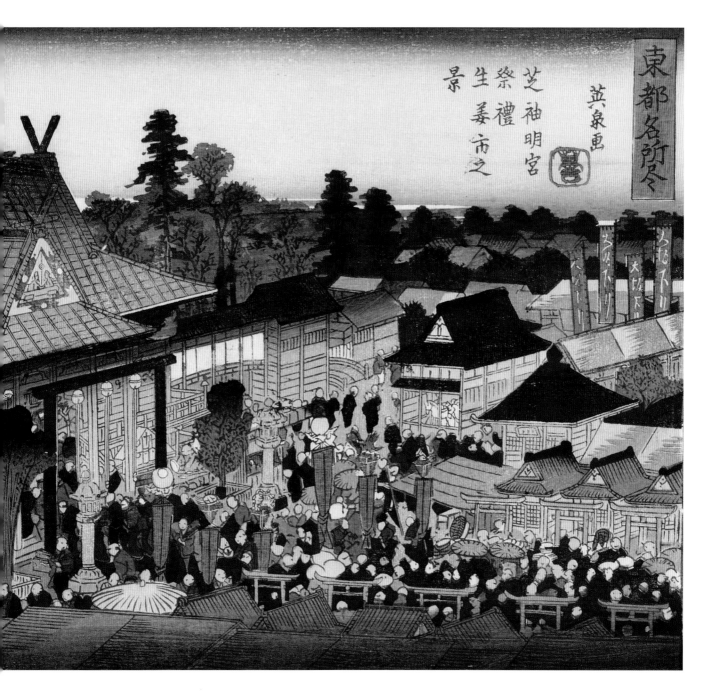

東都名所尽

英泉画

芝袖明宮
祭禮
生姜市之
景

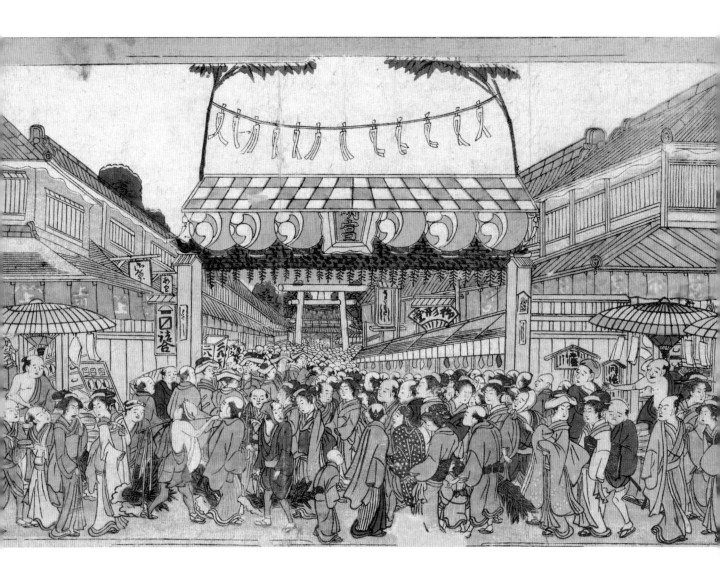

ABOVE Jostling crowds attend a festival. Ca. 1790s, Tamagawa Shucho, *View of Shinmeigu Shrine in Shiba* from the series *New Edition of Perspective Prints.*

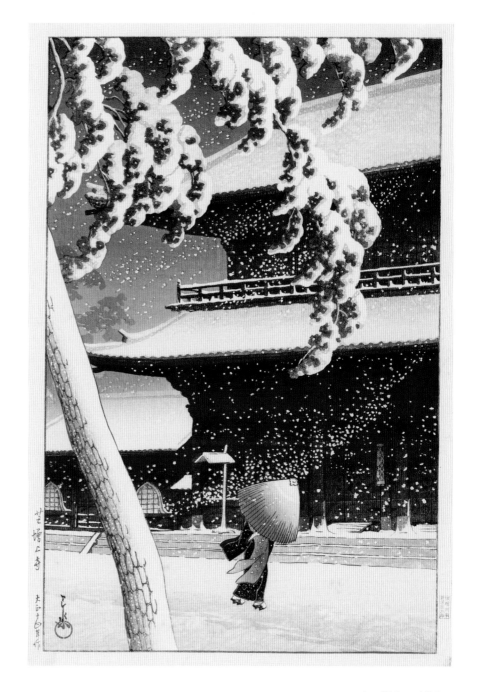

RIGHT The Sangedatsu Gate of Zozoji Temple, shown in this best-selling print, is designated an Important Cultural Property. 1925, Kawase Hasui, *Zojo Temple in Shiba,* from the series *Twenty Views of Tokyo.*

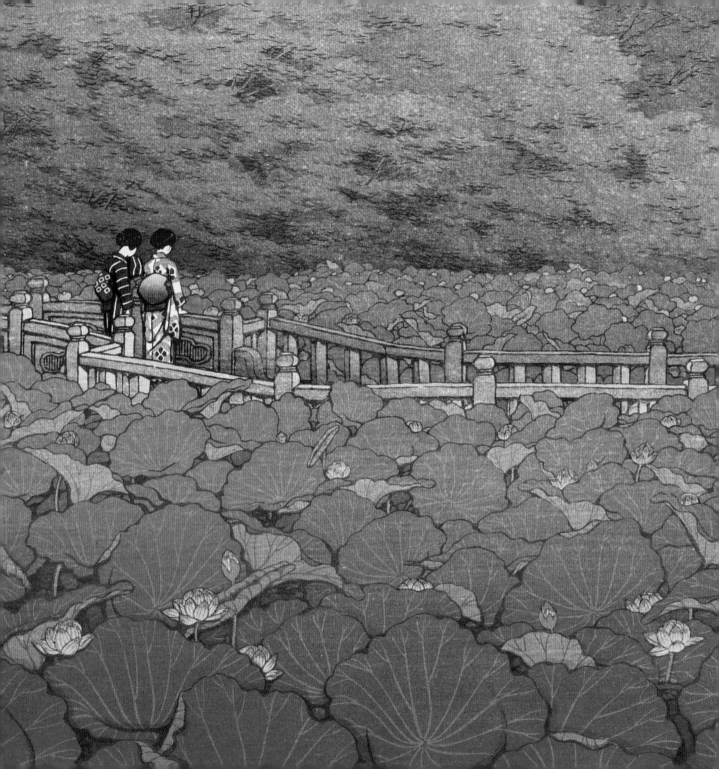

FACING PAGE Benten Pond at Zozoji Temple as depicted in this print no longer exists. All that remains is a small pond to the southeast of Tokyo Tower in what is now Shiba Park. 1929, Kawase Hasui, *The Pond at Benten Shrine in Shiba* (detail).

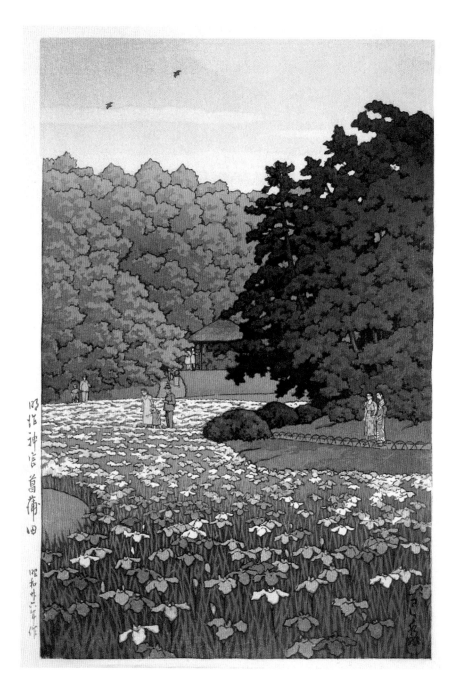

RIGHT Emperor Meiji designed the iris garden (*shobuda*) which is today part of the Inner Garden at Meiji Shrine and is most popular in June when the irises are in bloom. 1951, Kawase Hasui, *Iris Garden at Meiji Shrine.*

BELOW Kameido Tenjin Shrine in the east of the city is still home today to a picturesque drum-shaped bridge that attracts many visitors, especially when the wisteria is in bloom. 1941, Yoshida Toshi, *Half Moon Bridge.*

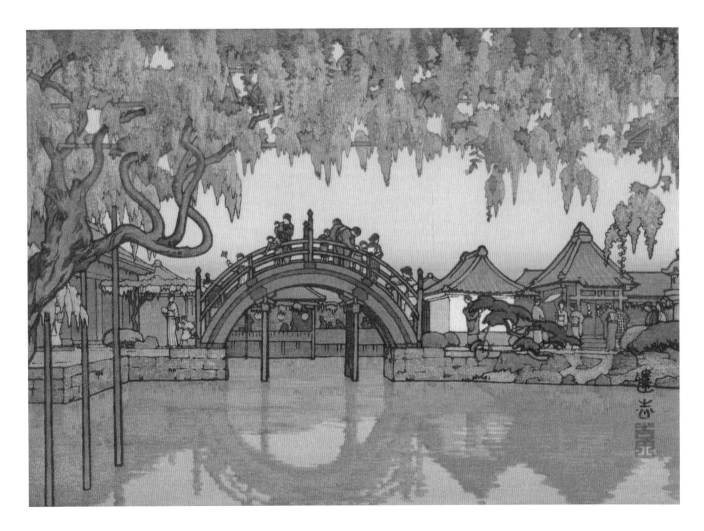

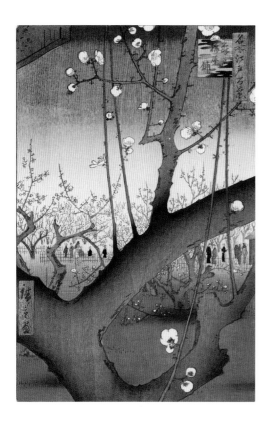

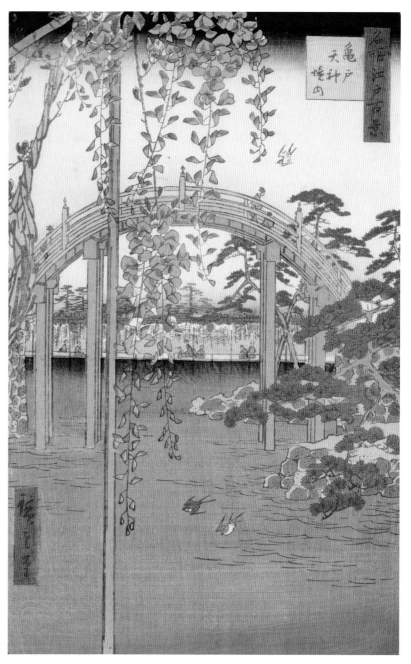

ABOVE This garden, called Seikoan (meaning *pure smell retreat*), with its three hundred plum trees, is documented in several photographs from the early twentieth century. Today nothing is left but a stone marker. 1857, Utagawa Hiroshige, *Plum Estate, Kameido*, from the series *One Hundred Famous Views of Edo.*

RIGHT Visitors enjoy the wisteria blooms. 1856, Utagawa Hiroshige, *Inside Kameido Tenjin Shrine*, from the series *One Hundred Famous Views of Edo.*

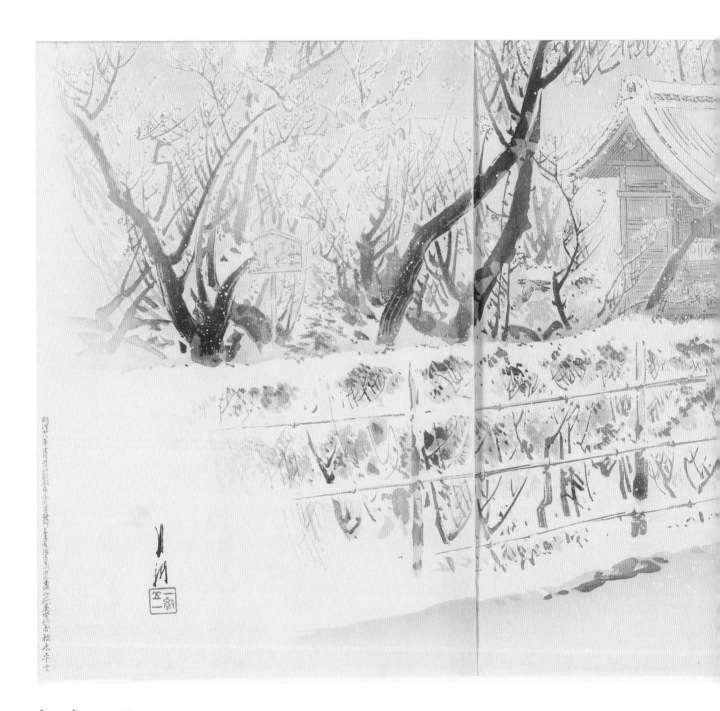

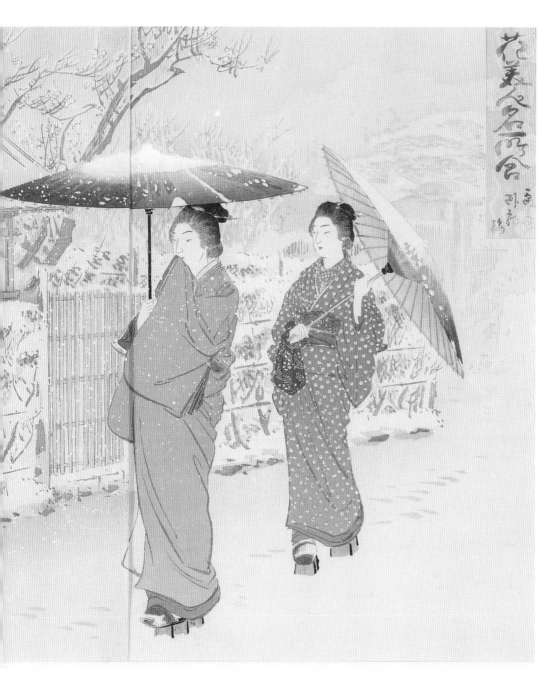

LEFT Named after its shape, the "Reclining-Dragon Plum" (*garyubai*) was arguably the best-known tree of Edo, located in the heart of the Seikoan plum garden. *1895, Ogata Gekko, **Reclining-Dragon Plum Tree at Kameido**, from the series **Comparison of Flowers, Beauties, and Famous Places**.*

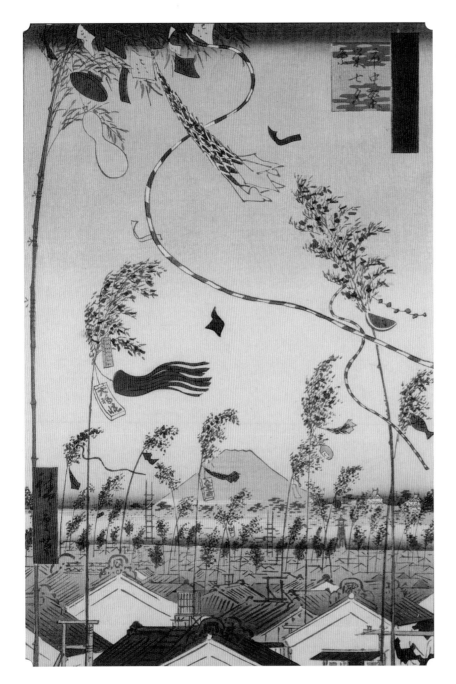

TOKYO FESTIVALS

The three great Shinto festivals of old Edo: the Kanda Matsuri, the Fukugawa Matsuri, and the Sanno Matsuri, still thrive in the twenty-first century, as do many other types of festivals. There are the autumn festivals held by every small Tokyo neighborhood in which portable shrines are carried to the local shrine, and there are also the festivals celebrated throughout the country, such as the Tanabata Festival in July, Boys' Day in May, and Girls' Day in March.

LEFT This type of outdoor display for the Tanabata Festival developed in the late Edo period. Bamboo branches decorated with slips of paper and other symbolic items were attached to rooftop ladders. 1857, Utagawa Hiroshige, *The City Flourishing, Tanabata Festival*, from the series *One Hundred Famous Views of Edo*.

RIGHT The Sanno Matsuri remains to this day one of Tokyo's three most important festivals. 1886, Tsukioka Yoshitoshi, *Dawn Moon of the Shinto Rites–The Old Sanno Festival*, from the series *One Hundred Aspects of the Moon.*

BELOW Carp streamers fly on Boys' Day as parents pray that their children will be strong and vigorous. 1857, Utagawa Hiroshige, *Suido Bridge, Surugadai* from the series *One Hundred Famous Views of Edo.*

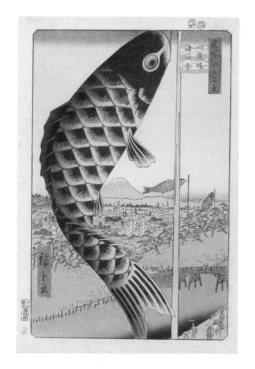

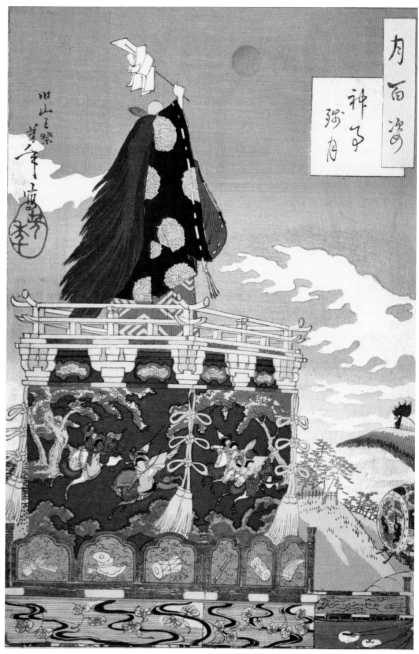

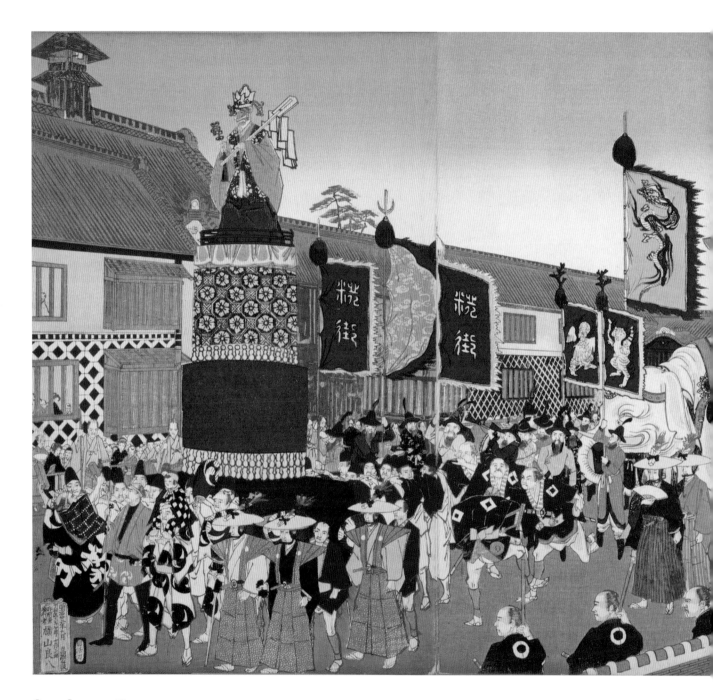

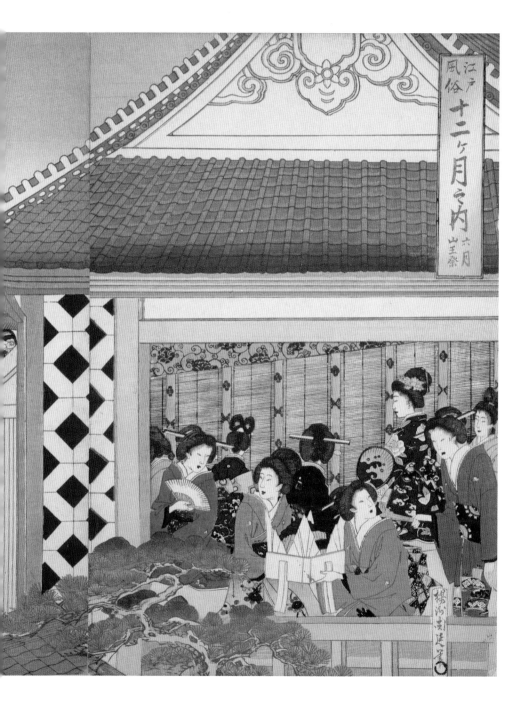

LEFT Sanno Festival processions featured life-size mechanical figures such as the Shinto priest and white elephant pictured here. 1889, Toyohara Chikanobu, *June: Sanno Festival,* from the series *The Customs and Manners of Edo within Twelve Months.*

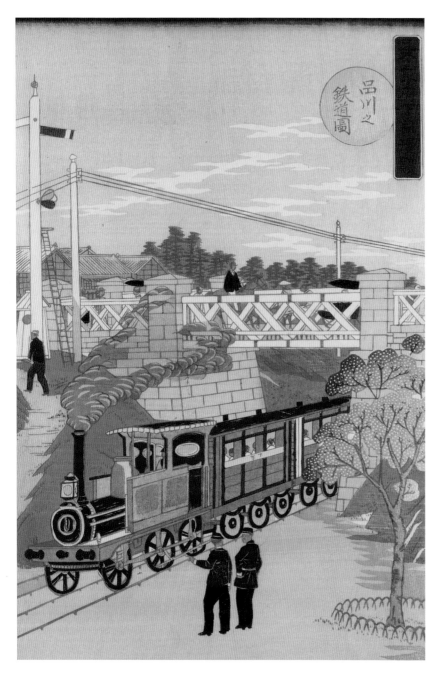

RAILWAYS

Japan's first railway was constructed in 1872 to connect Yokohama to the Shinagawa district of Tokyo. Shinagawa served as Tokyo's station until Shinbashi Station was built further north. The line from Yokohama to Shinagawa opened on June 12, 1872 with a temporary service. Only two trains per day were run, each taking 43 minutes. On October 14, 1872, Emperor Meiji came to Shinbashi to officially take the line into operation and he rode on the first train to Yokohama.

LEFT Shinagawa Station was Tokyo's first, provisional station. 1874, Utagawa Hiroshige III, *Picture of the Railway at Shinagawa*, from the series *Mirror of the Pride of Tokyo Prefecture*.

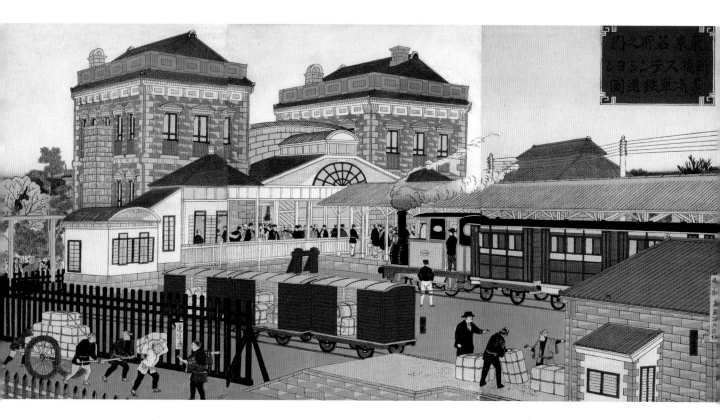

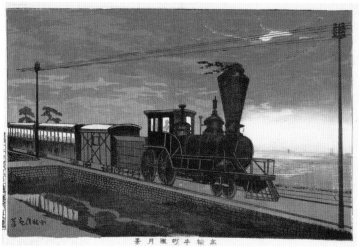

ABOVE Shinbashi Station was Tokyo's main terminal from 1872 until 1914, when the new Tokyo Station opened. Ca. 1870s, Utagawa Hiroshige III, *The Steam Train at Shinbashi Station* from the series *The Famous Places of Tokyo*.

LEFT Today's Shinagawa Station used to be Takanawa Station until it was renamed in 1924 and relocated to its present site in 1933. 1879, Kobayashi Kiyochika, *View of Ushimachi in Takanawa by Hazy Moonlight*.

RIGHT Ueno Station opened on July 28, 1883, but was destroyed in the 1923 Great Kanto Earthquake. In 1932 the station was rebuilt, and still stands today. 1885, Nogawa Tsunekichi, *View of Ueno-Nakasendo Railway from Ueno Station, Tokyo*.

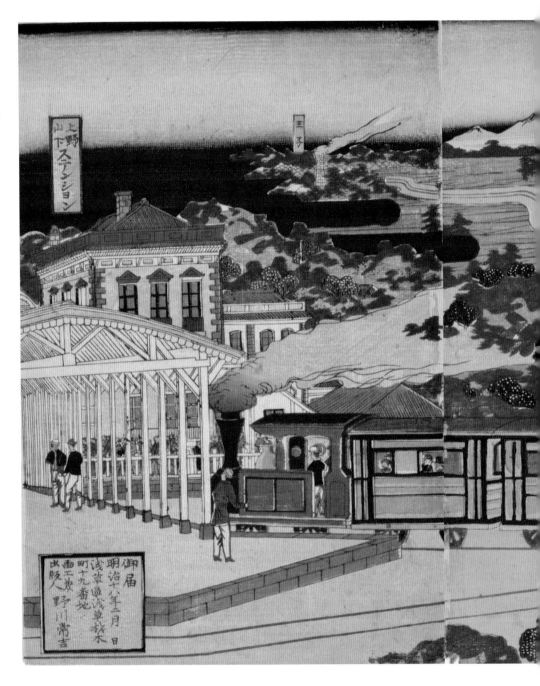

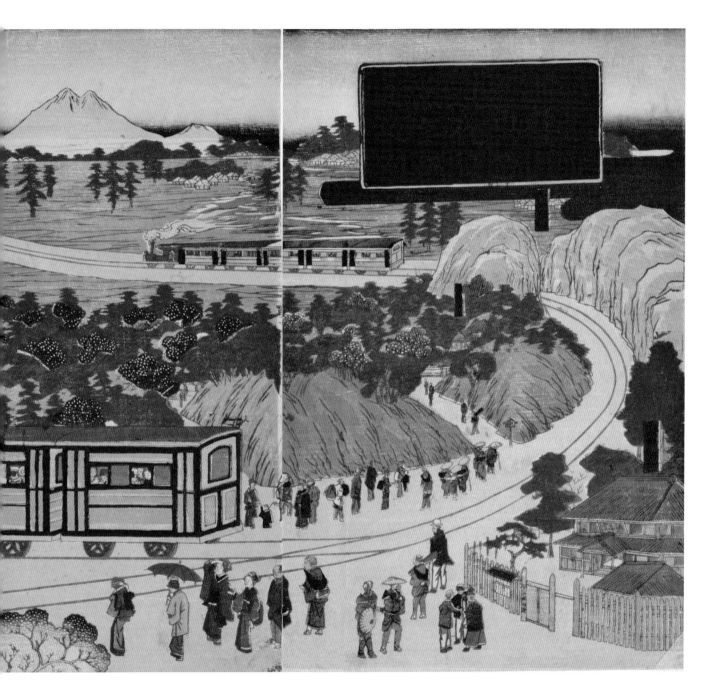

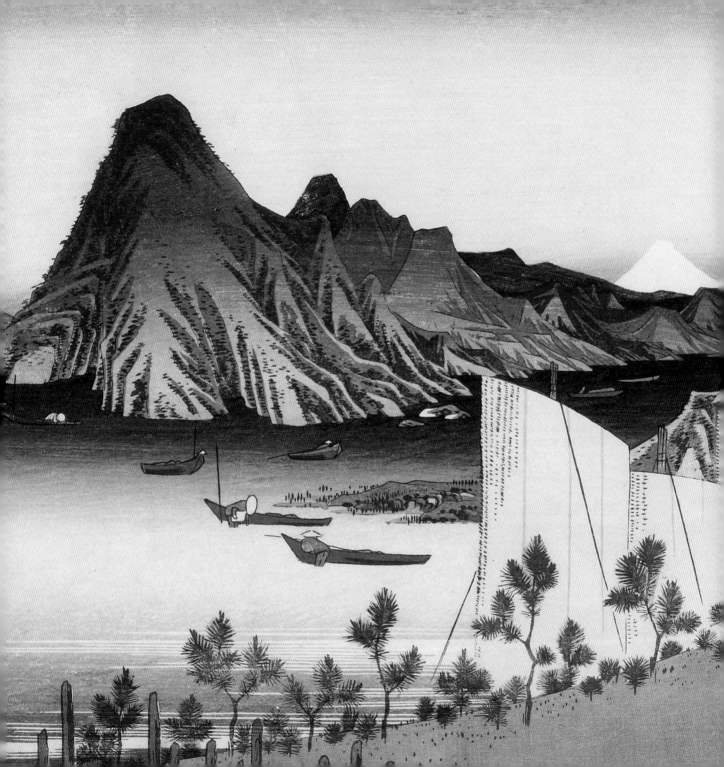

Sights Around Tokyo

Popular tourist destinations close to Tokyo remain
the same today as they did a hundred years ago.
These include Mount Fuji, fifty miles to the
southwest of the city; the hot springs resort of
Hakone in Fuji's foothills; Tokyo's neighboring port
city of Yokohama; the seaside town of Kamakura,
Japan's ancient capital whose streets are lined
with historically significant shrines and temples;
and the mountain town of Nikko, home
to the historic Toshogu Shrine.

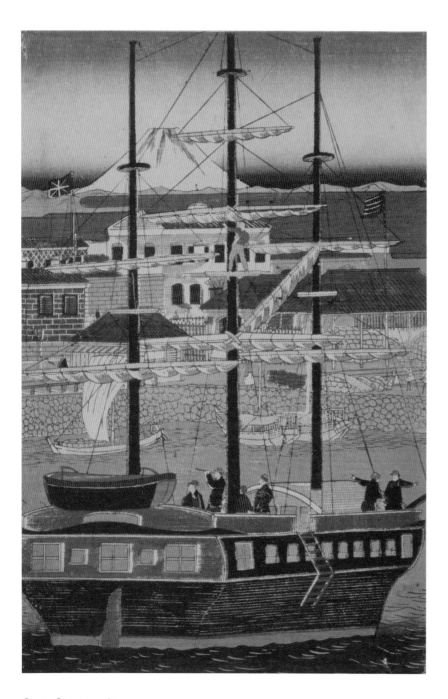

YOKOHAMA

After Commodore Matthew Perry and his fleet of American warships forced Japan to open for commerce in 1853–54, a trading port for foreign ships was established in the sleepy fishing village of Yokohama in 1859. A rapid influx of foreigners soon caused Yokohama to grow exponentially and the city saw the birth of many modern innovations, such as the first daily newspaper. Today Yokohama is Japan's second largest city, with a population of 3.7 million recorded in 2013.

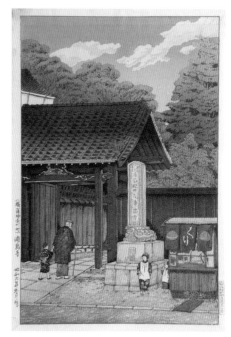

PAGE 80 Ca. 1832–1833, Utagawa Hiroshige, *Maisaka: View of Imagiri* (detail), from the series *The Fifty-three Stations along the Tokaido.*

PAGE 81 1852, Utagawa Hiroshige, *Tonosawa,* from the series *Pictures of Seven Hot Springs of Hakone.*

FACING PAGE. LEFT 1872, Utagawa Hiroshige III, right sheet of the triptych *View of Foreign Ships at the Seafront in Yokohama.*

FACING PAGE. RIGHT 1831, Ishiwata Koitsu, *Urashima Temple in Yokohama's Kanagawa Town.*

THIS PAGE 1880s, Utagawa Kunimatsu, *Competition of Famous Places in Yokohama: The Post Office at Motomachi-dori.*

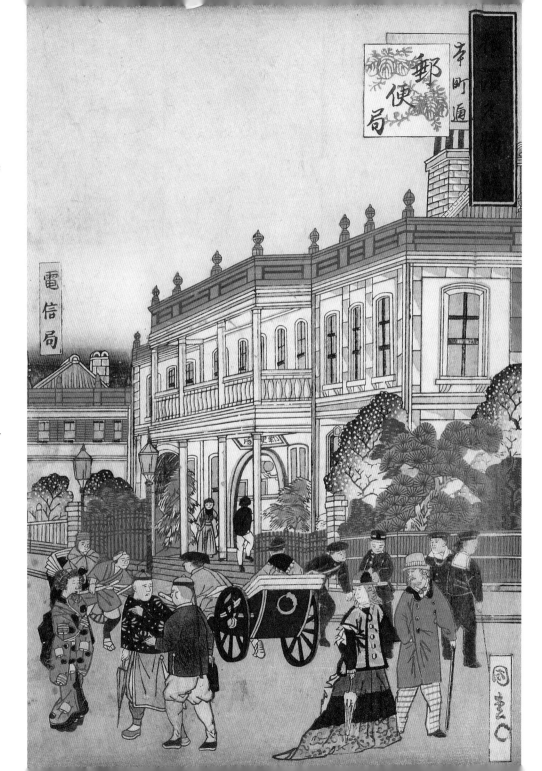

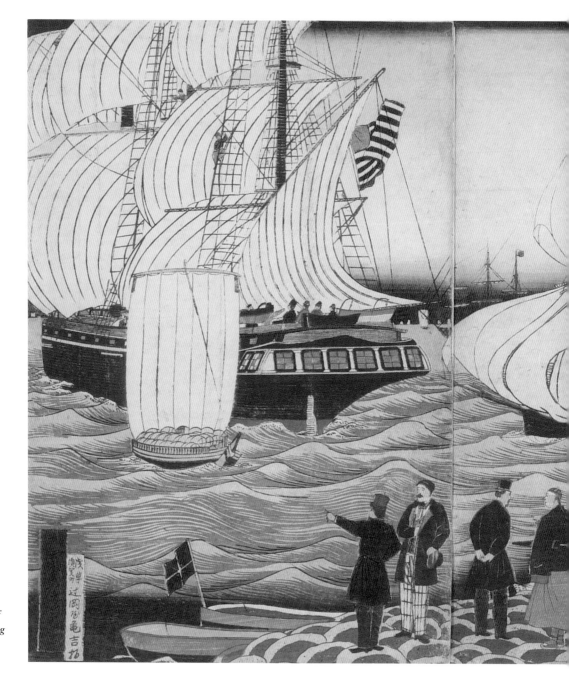

RIGHT By the 1870s, the once-sleepy village of Yokohama was a thriving port, with a multinational population and modern stone buildings lined up along the waterfront. Ca. 1875, Utagawa Hiroshige III, *True View of the Foreign Buildings along the Kaigandori Seen from the Yokohama Wharves.*

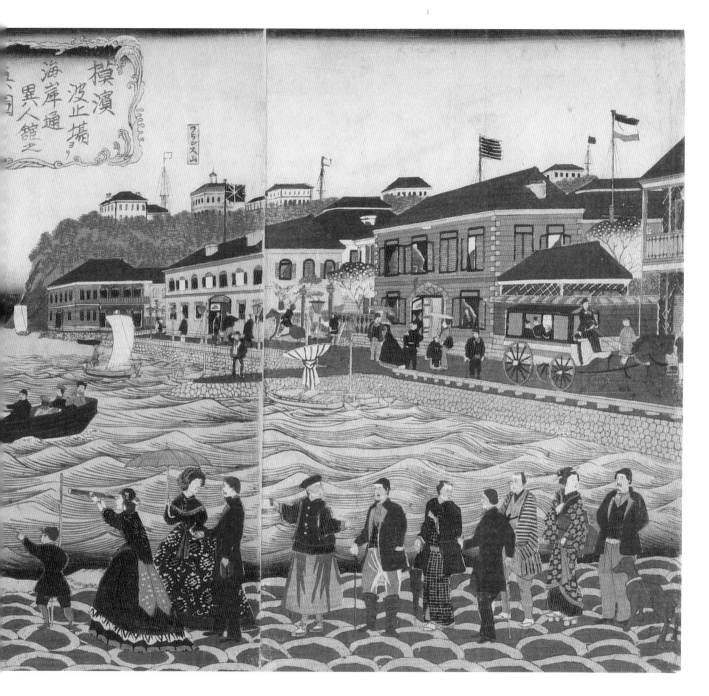

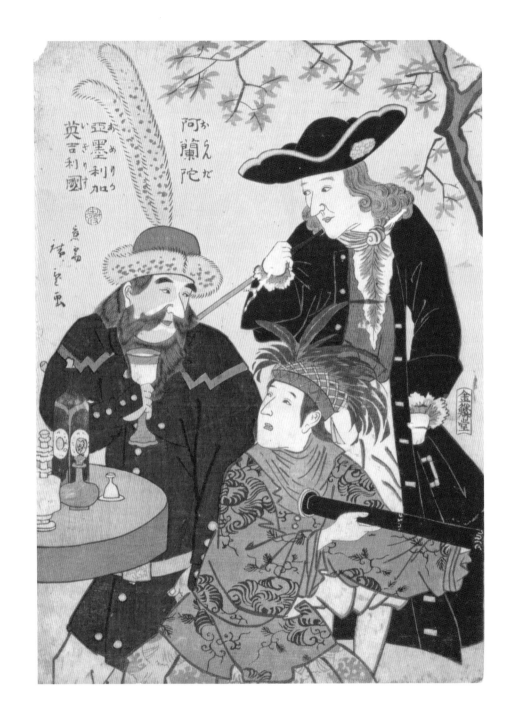

あ阿ら蘭え陀だ

あめ亞り墨か利ら加ガ

いぎ英り吉す利國

広重画

金鱗堂

RIGHT The rapid influx of foreigners
to Yokohama provided much
inspiration for woodblock print artists
of the day. 1860, Utagawa Hiroshige
II, *Dutch, American, English*.

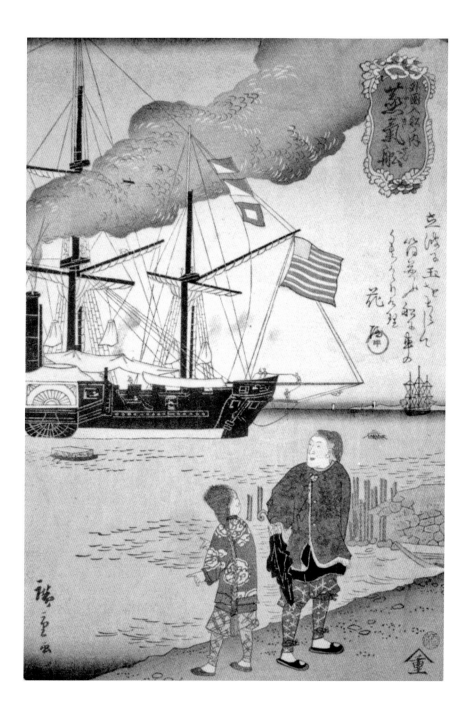

LEFT Foreign steamships became a common sight off the Yokohama coast from the end of the nineteenth century. 1861, Utagawa Hiroshige II. *Steamship* from the series *The Arriving Ships from Foreign Countries.*

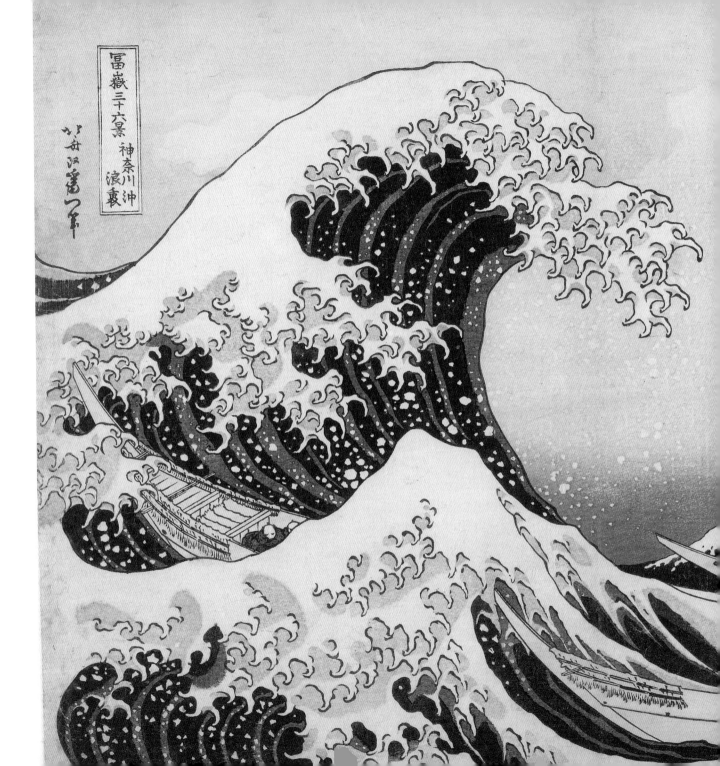

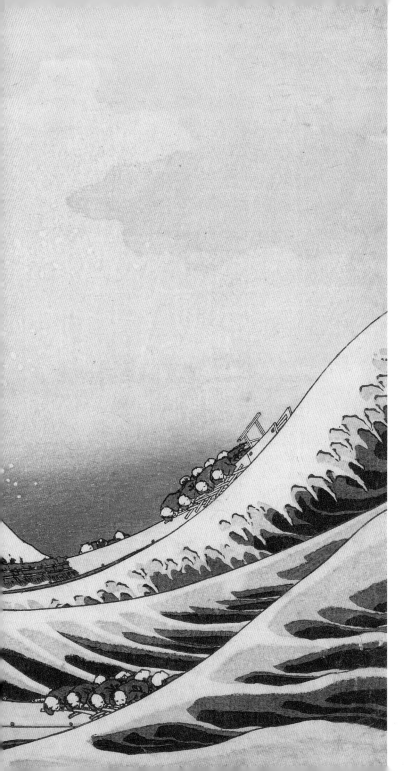

LEFT Widely known as "The Great Wave," Hokusai's dynamic and dramatic print surpassed all previous renditions of the wave motif by other artists and by Hokusai himself. The location is today believed to be close to Yokohama. Ca. 1830–31, Katsushika Hokusai, *Under the Wave off Kanagawa,* from the series *Thirty-six Views of Mount Fuji.*

KAMAKURA

Thirty miles south west of Tokyo, the town of Kamakura was the seat of Japan's government from 1192 until 1333. In 1526 much of the town was burnt to the ground during a siege, and the town was destroyed again by the 1923 Great Kanto Earthquake whose epicenter was nearby. A common subject of woodblock prints was the view of Mount Fuji and the island of Enoshima as viewed from Seven Ri Beach. In the early twentieth century Kamakura's many historically significant Buddhist and Shinto sites also became popular motifs for print artists. Sometimes called the Kyoto of eastern Japan, Kamakura is a popular tourist destination today.

RIGHT Tsurugaoka Hachimangu, Kamakura's most important Shinto shrine, was founded in 1063 and moved to its present location in 1191. Ca. 1830, Utagawa Toyokuni II, *Evening Bell at Kamakura: View of the Mountains of Awa Province from Tsurugaoka,* from the series *Eight Views of Scenic Spots.*

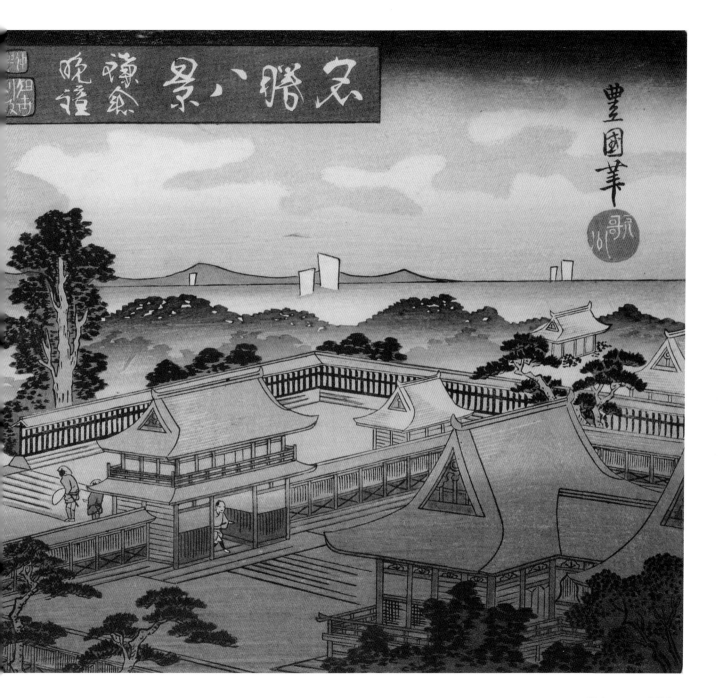

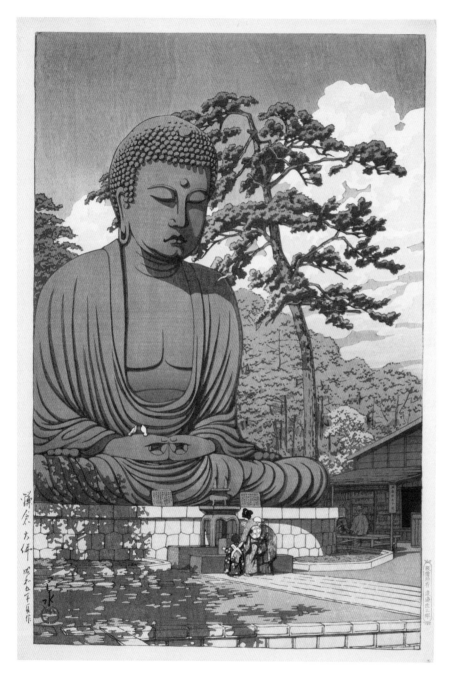

LEFT Completed in 1252, the Great Buddha of Kotoku-in Temple is a 44-foot-high hollow bronze statue that can also be viewed from the inside. 1930, Kawase Hasui, *The Great Buddha at Kamakura.*

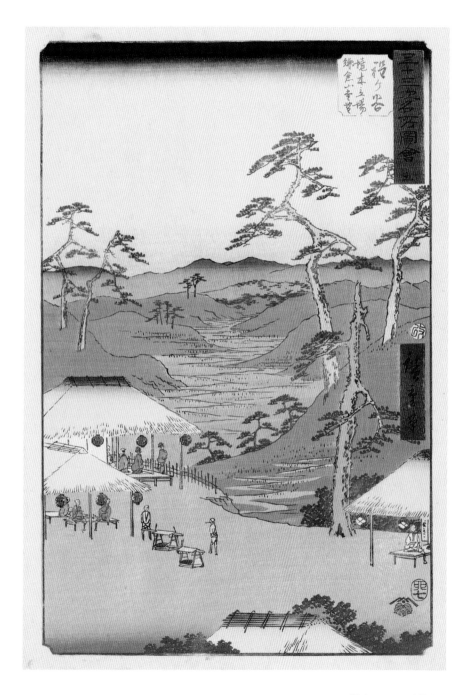

RIGHT Hodogaya is today a built-up suburb of Yokohama. 1855, Utagawa Hiroshige, *No. 5, Hodogaya: Distant View of the Kamakura Mountains from the Boundary Tree Posthouse*, from the series *Pictures of Famous Places along the Fifty-three Stations.*

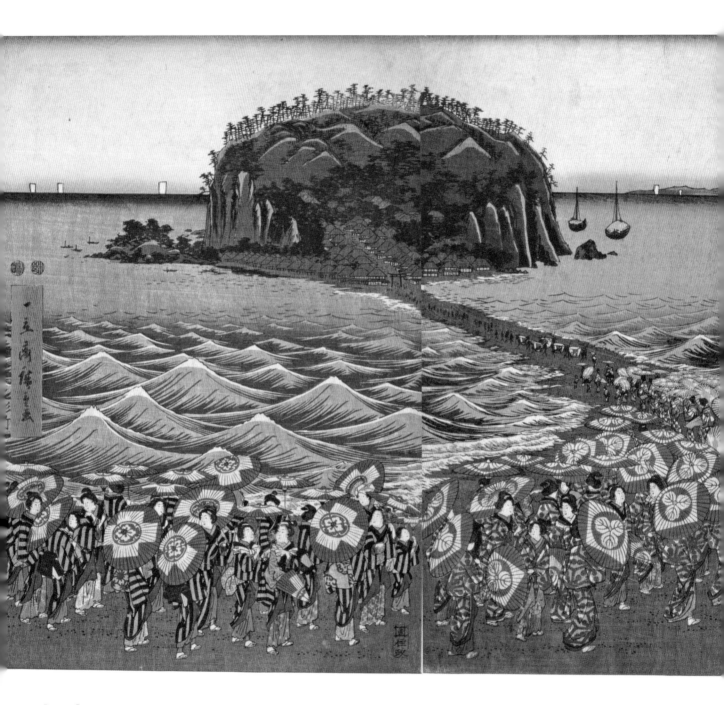

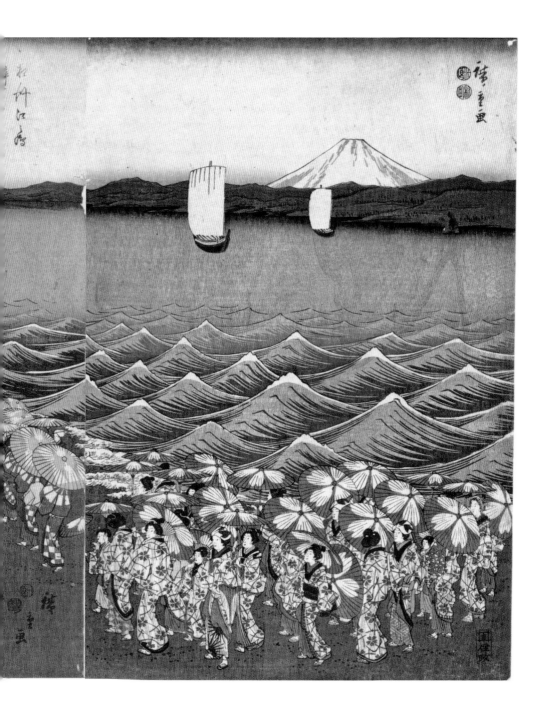

LEFT Benzaiten, the goddess of music and entertainment, is enshrined on the island of Enoshima, west of Kamakura. Ca. 1850, Utagawa Hiroshige, *View of the Opening of Benzaiten Shrine at Enoshima in Soshu.*

NIKKO

This small town is about 87 miles north of Tokyo, in the mountains of the former Shimotsuke Province (now Tochigi Prefecture). Famous for some spectacular waterfalls and as a viewing spot for autumn leaves, Nikko also established itself as a spiritual site because of its remote location, ideal for those seeking solitude. Rinnoji Temple was founded here in the eighth century, and the temple complex includes the mausoleum of the third Tokugawa shogun, Iemitsu (1604–1651). The Toshogu Shrine, founded in 1617 is dedicated to the first Tokugawa shogun, Ieyasu (1543–1616), and his remains are entombed here. Along with nearby Futarasan Shrine, Toshogu and Rinnoji were designated World Heritage Sites in 1999.

Due to Nikko's remoteness, it features in relatively few woodblock prints. Eisen's series *Famous Sights in the Mountains of Nikko* from the mid-1840s focuses only on waterfalls, although growing interest in depicting Nikko's other sites can be noted from the 1880s onward.

BELOW The famous 90-foot-long red Sacred Bridge (*shinkyo*) belongs to Futarasan Shrine and, according to legend, dates back to the 8th century. 1930, Kawase Hasui, *Snow at the Sacred Bridge in Nikko.*

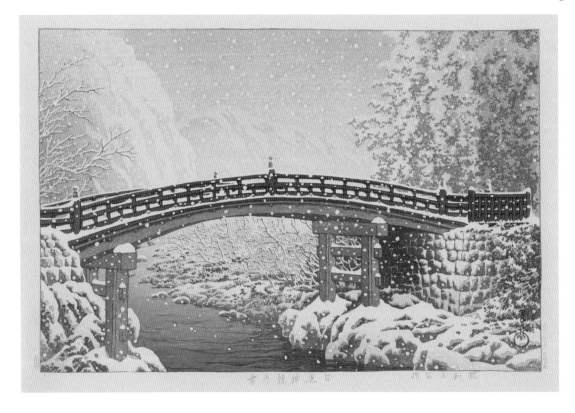

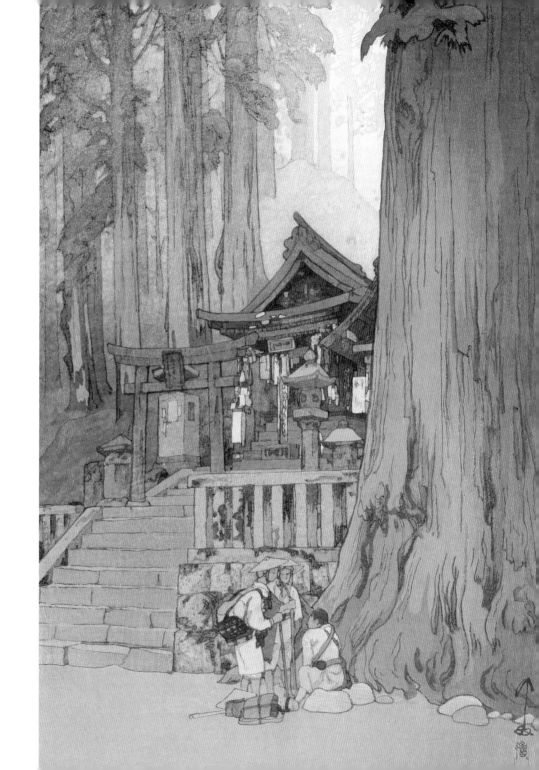

RIGHT The small shrine above the three pilgrims could be Hiei Shrine which was built in the mid-17th century. 1937, Yoshida Hiroshi, *Misty Day in Nikko.*

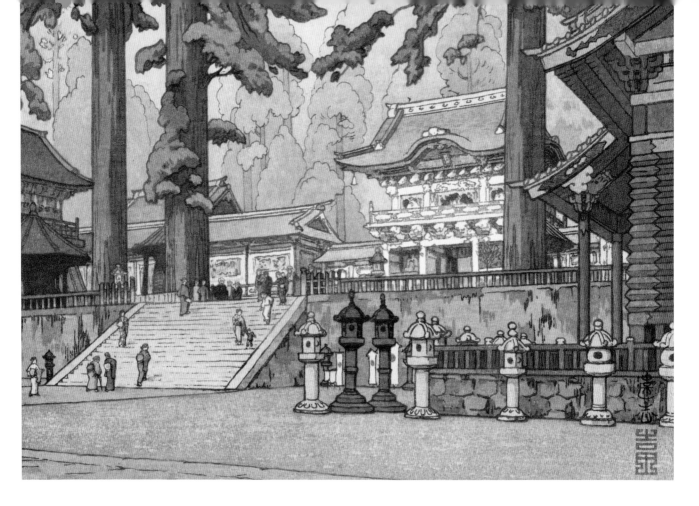

ABOVE Toshogu Shrine is home to the mausoleum of Tokugawa Ieyasu (1543–1616), founder and first shogun of the Tokugawa shogunate that ruled Japan for over two hundred and fifty years. 1940, Yoshida Toshi, *Nikko*.

LEFT Rinnoji Temple is considered Nikko's most important. It is well known for its meditation garden, which draws many visitors. 1941, Yoshida Toshi, ***Rinno Temple Garden***.

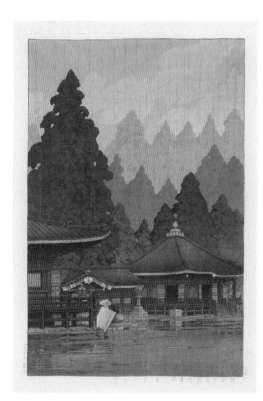

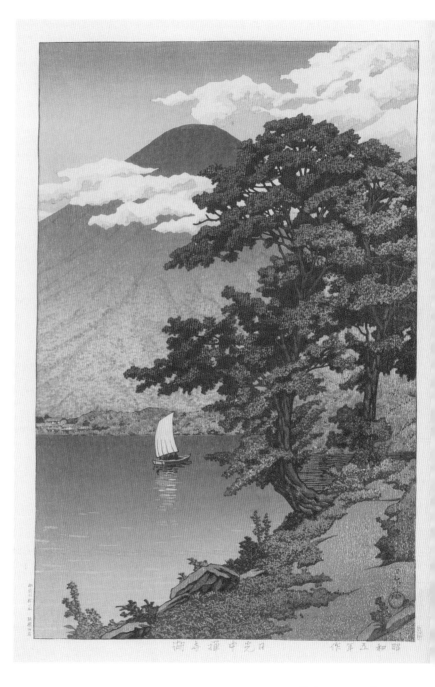

ABOVE Futatsu Hall is part of
Rinnoji, a complex of fifteen Buddhist
temples. 1929, Kawase Hasui, *Futatsu
Hall at Nikko.*

RIGHT In the mountains above Nikko
is the scenic Lake Chuzenji, a popular
destination not just in autumn, but
also when the cherry blossoms are
blooming in spring. 1930, Kawase
Hasui, *Lake Chuzenji at Nikko.*

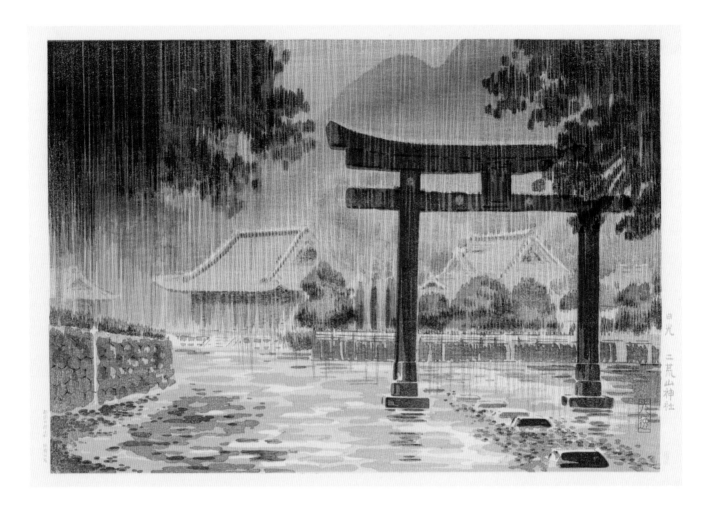

ABOVE Futarasan consists of three shrine buildings situated on Mount Nantai. Early 1930s, Tsuchiya Koitsu *Futarasan Shrine in Nikko.*

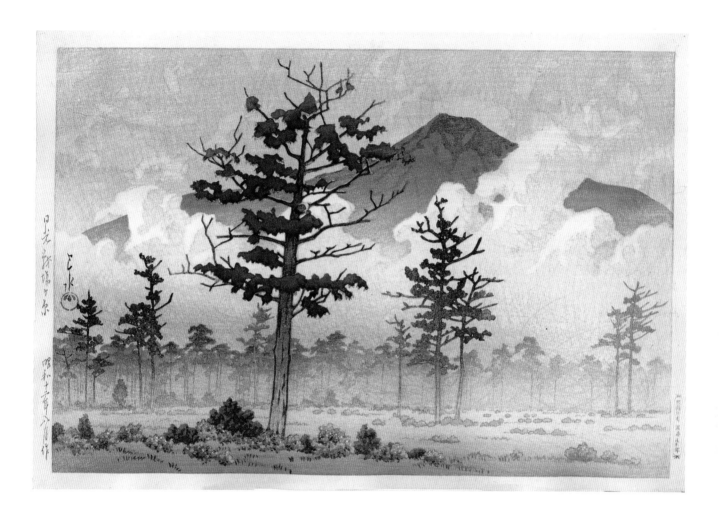

ABOVE The Senjogahara Plateau is a large marshland in the mountains above Nikko and belongs to Nikko National Park. 1937, Kawase Hasui, *Senjogahara, Nikko.*

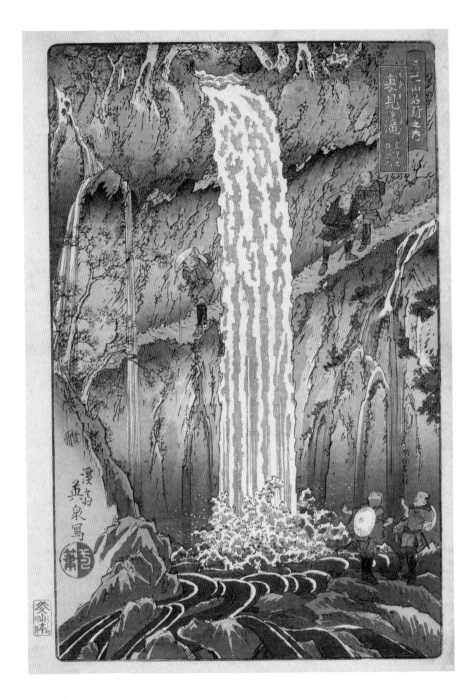

LEFT The mountains around Nikko are home to some spectacular waterfalls. Ca. 1842–1846, Keisai Eisen, *Backward-viewing Falls, One of the Three Waterfalls,* from the series *The Famous Places in the Mountains of Nikko.*

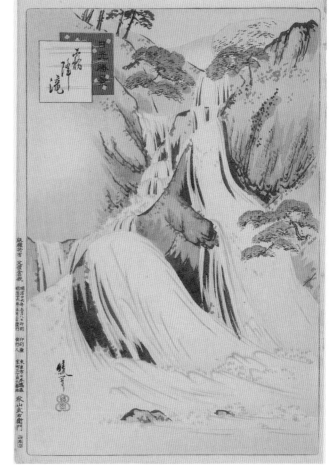

BELOW An autumn view of Nikko's Kirifuri waterfall. 1893, Ayaoka Yushin, *Kirifuri Waterfalls*, from the series *Fine Views of Nikko*.

ABOVE As scenic spots, waterfalls are a frequent motif in the arts of Japan. Ca. 1842–1846, Keisai Eisen, *Noodle Falls*, from the series *The Famous Places in the Mountains of Nikko*.

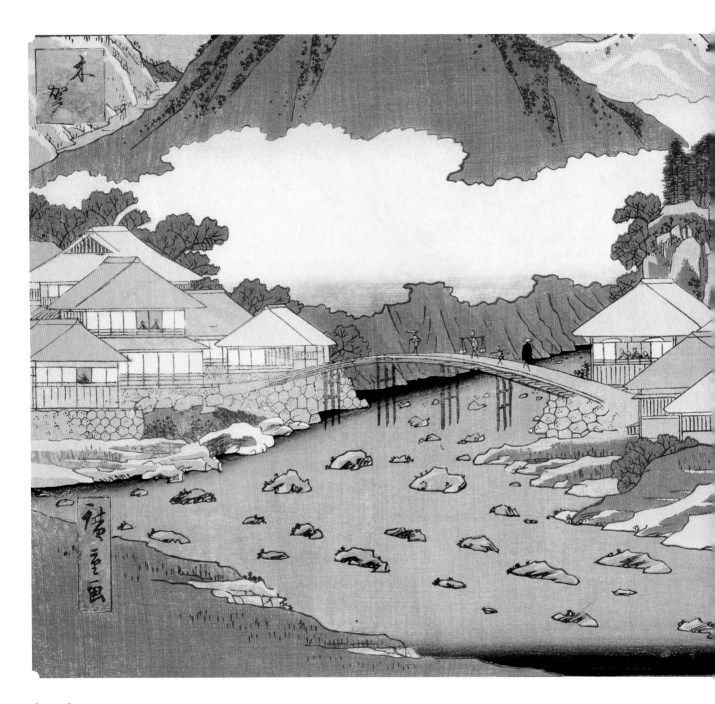

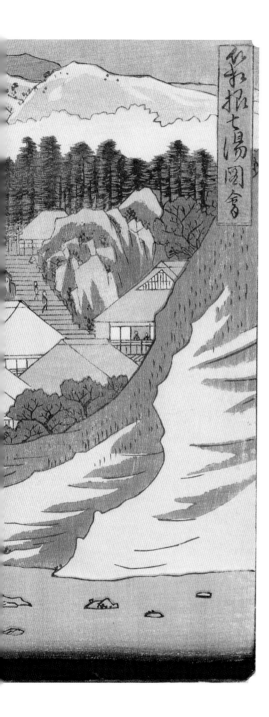

HAKONE

The town of Hakone, located in what was known as Sagami Province during the Edo period and is now known as Kanagawa Prefecture, is popular for its hot springs and the scenic beauty lent by its proximity to Mount Fuji. The Hakone Checkpoint, opened in 1619 and in operation until 1869, was one of two official checkpoints along the Tokaido highway, where travelers had their permits and baggage examined. In 2007, the checkpoint was restored to its original form and is now an open-air museum.

LEFT Volcanically active Hakone has an abundance of natural hot springs. 1852, Utagawa Hiroshige, *Kiga,* from the series *Pictures of Seven Hot Springs of Hakone.*

BELOW Countryside hot spring resorts often have lodging facilities and serve elaborate meals. Ca. 1837, Utagawa Hiroshige, *Hot Spring at Hakone,* from the series *Famous Places of Our Country.*

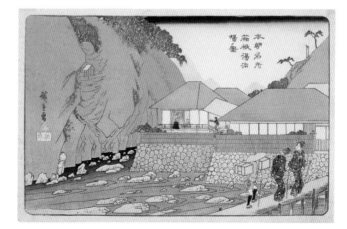

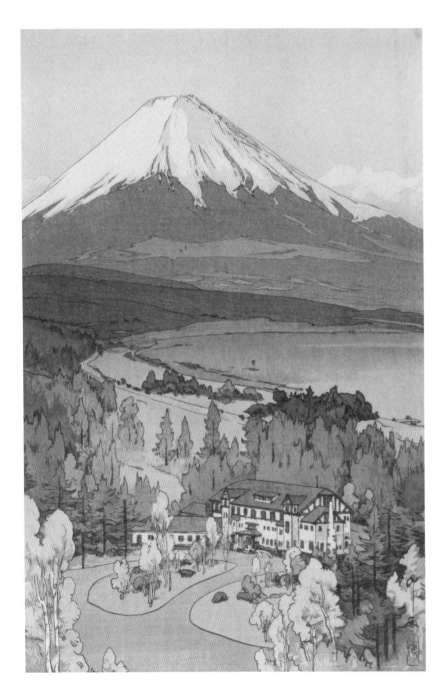

LEFT This world-famous hotel, in operation from 1936 to 1975, was a popular place to stay for visitors to the Fuji-Hakone-Izu National Park, and attracted foreign guests such as Charlie Chaplin and Jean Cocteau. Ca. 1937, Yoshida Hiroshi, *Fuji New Grand Hotel, Lake Yamanaka.*

BELOW Two women dressed in light kimono enjoy the view from the balcony of their hot spring. The waterfall in the background might be Shiraito, considered one of Japan's most beautiful. 1851, Utagawa Hiroshige, *Hakone,* from the series *Fifty-three Stations.*

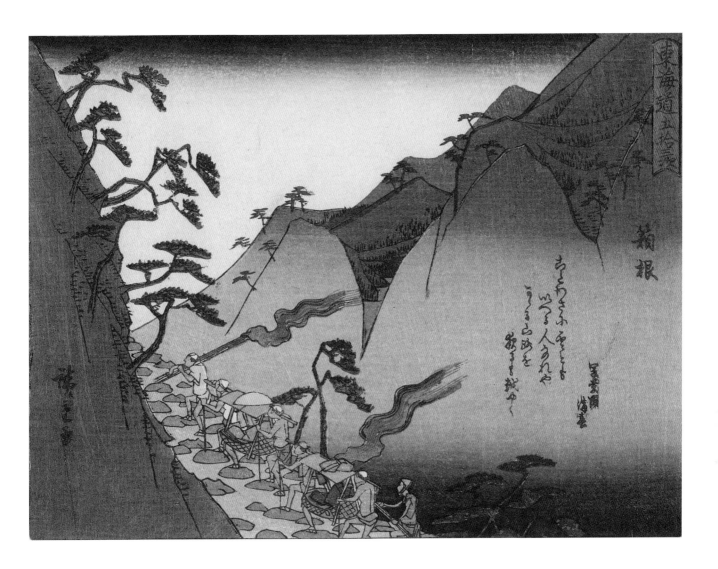

ABOVE Porters carry travelers in
sedans along a mountain path near
Hakone. Huge torches light the way.
1840, Utagawa Hiroshige, *Hakone*,
from the series *Fifty-three Stations
along the Tokaido.*

RIGHT This teahouse near Hakone has been serving *amazake*, a sweet, non-alcoholic beverage, since the seventeenth century. 1881, Kobayashi Kiyochika, **Amazake Store in Hakone Mountain Pass.**

BELOW The five lakes in the foothills of Mount Fuji are popular tourist spots. 1851, Utagawa Hiroshige, *Lake in the Mountains of Hakone*, from the series **Thirty-six Views of Mount Fuji.**

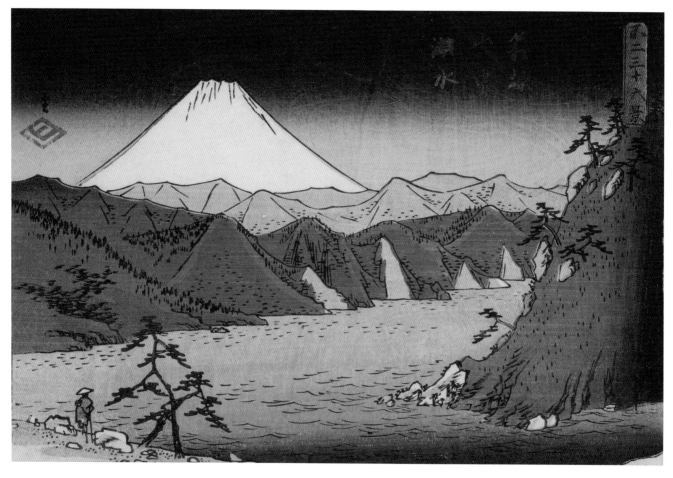

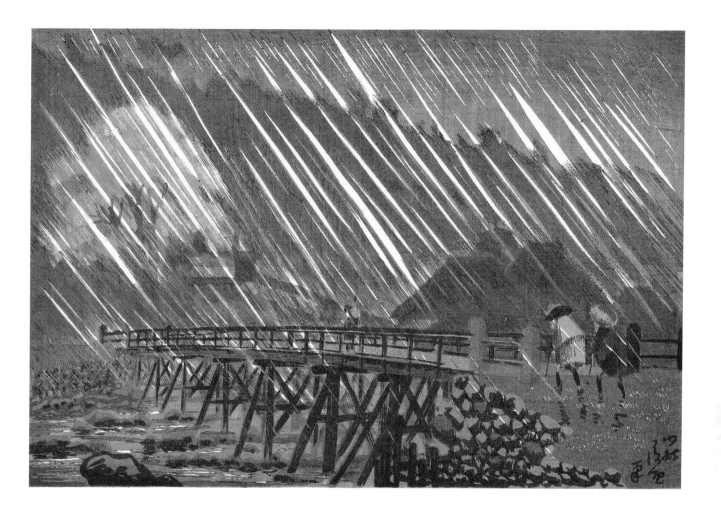

ABOVE The Tokaido road crossed over Hakone's Mitsueda Bridge. Ca. 1880, Kobayashi Kiyochika, *Rain at Mitsueda Bridge in Hakone.*

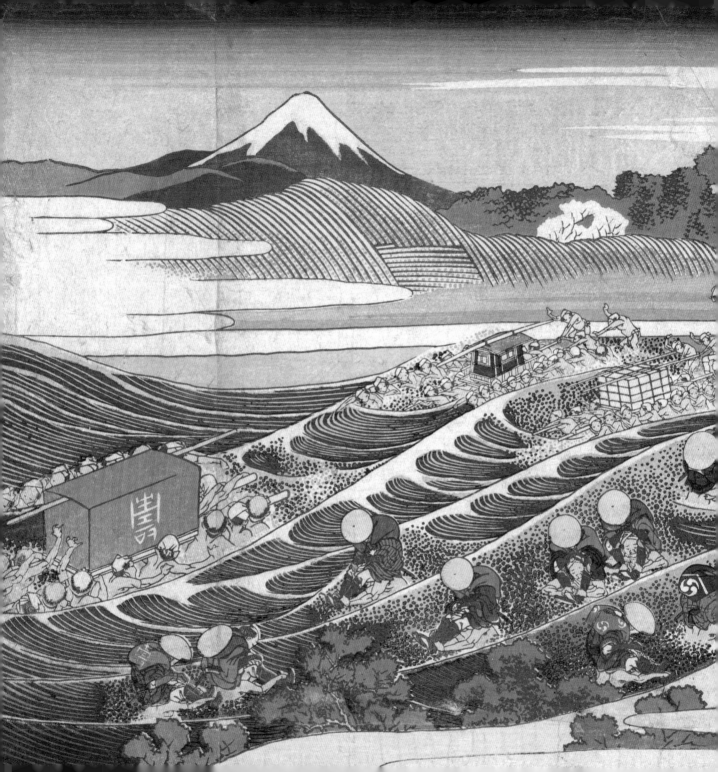

MOUNT FUJI

Mount Fuji, at 12,388 feet the highest mountain in Japan, has been worshipped since ancient times and is arguably the country's best-known symbol. An imposing single peak soaring into the sky, the mountain is an active volcano that last erupted in 1708. Its location next to the Tokaido, a heavily trafficked highway in the Edo period, made it a common subject for woodblock prints. Fuji is one of Japan's "three holy mountains" (along with Mount Tate and Mount Haku) and in 2013 was added to the UNESCO World Heritage List.

FACING PAGE Ca. 1830–31, Katsushika Hokusai, *Fuji from Kanaya on the Tokaido*, from the series *Thirty-six Views of Mount Fuji*.

BELOW Ca. 1830–31, Katsushika Hokusai, *Rainstorm beneath the Summit*, from the series *Thirty-six Views of Mount Fuji*.

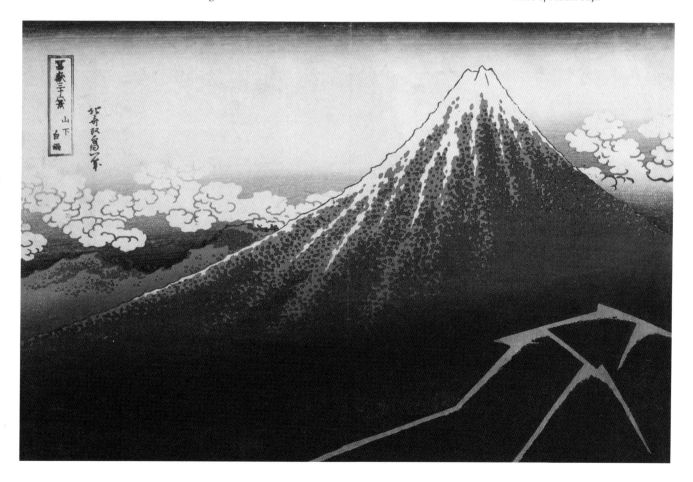

Ca. 1832–33, Utagawa Hiroshige, *Hara: Fuji in the Morning* from the series *The Fifty-three Stations along the Tokaido.*

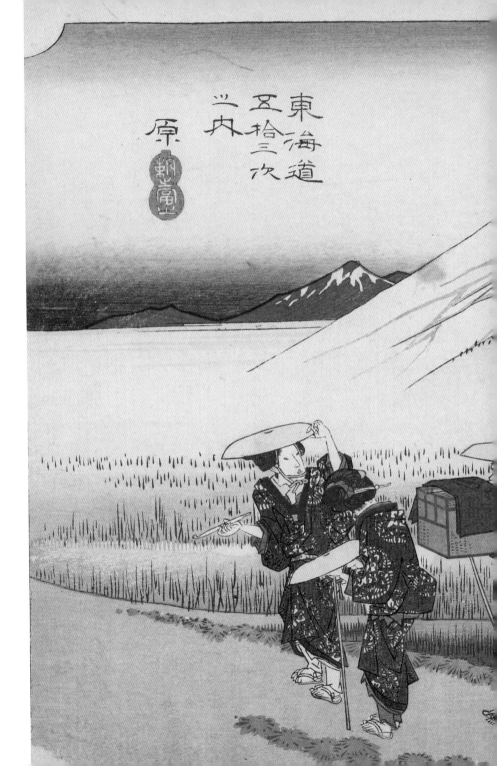

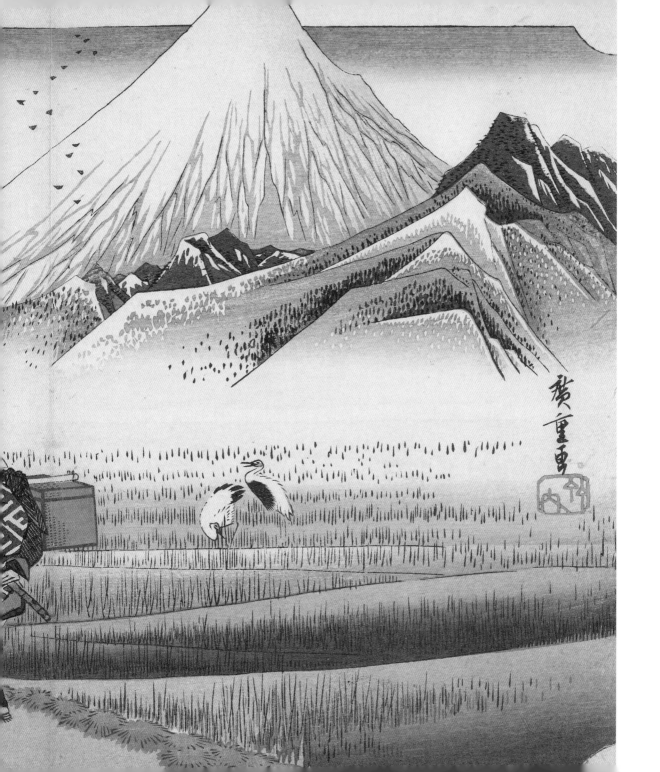

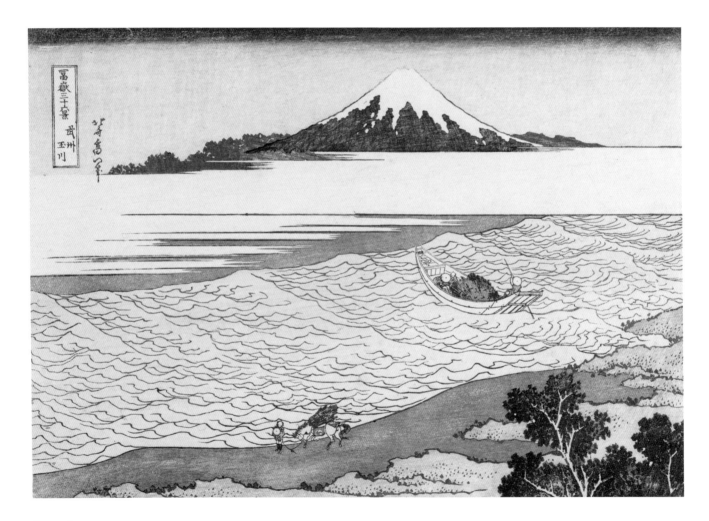

BELOW The Tama River is the natural boundary between Tokyo and Kawasaki Prefecture. Boats transported people and goods across the river. Ca. 1830–31, Katsushika Hokusai, *The Tama River in Musashi Province*, from the series *Thirty-six Views of Mount Fuji*.

TOP These types of print, known as *uchiwa-e*, were designed as a decoration for a fan. For this reason, few copies of the landscapes depicted on this page have survived to the present day. 1852, Utagawa Kuniyoshi, *Fuji from Mimeguri*, from the series *Thirty-six Views of Mount Fuji*.

BOTTOM Another *uchiwa-e* perspective of Mount Fuji. *1855, Utagawa Hiroshige, Shichirigahama Beach at Kamakura in Sagami.*

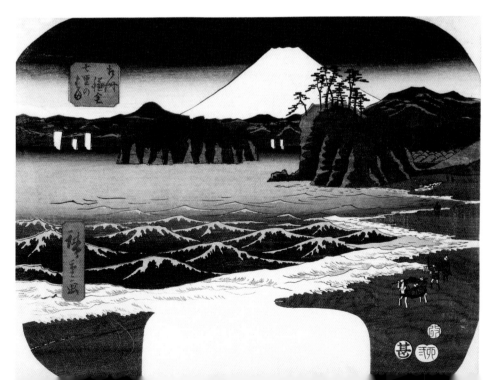

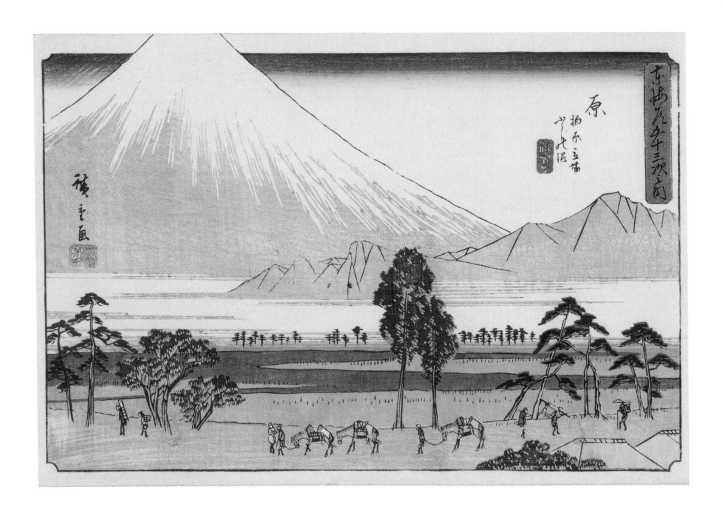

ABOVE The rugged peaks of the volcano Mount Ashitaka, southeast of Mount Fuji, are visible on the right. Ca. 1841-1842, Utagawa Hiroshige, *Hara: The Rest Stop at Kawashibara and the Fuji Swamp, from the series The Fifty-three Stations along the Tokaido Road.*

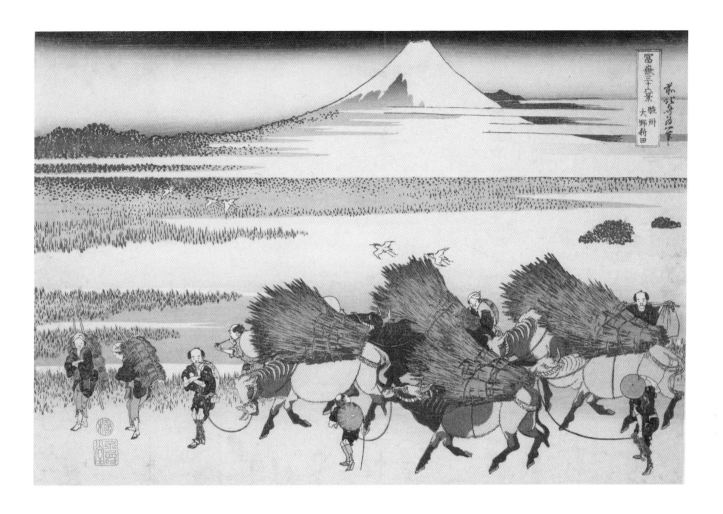

ABOVE Having finished their early morning labors, women carrying bundles of grass are followed by farmers leading oxen loaded with bundles of reeds. Ca. 1830–31, Katsushika Hokusai, *The Paddies of Ono in Suruga Province*, from the series *Thirty-six Views of Mount Fuji*.

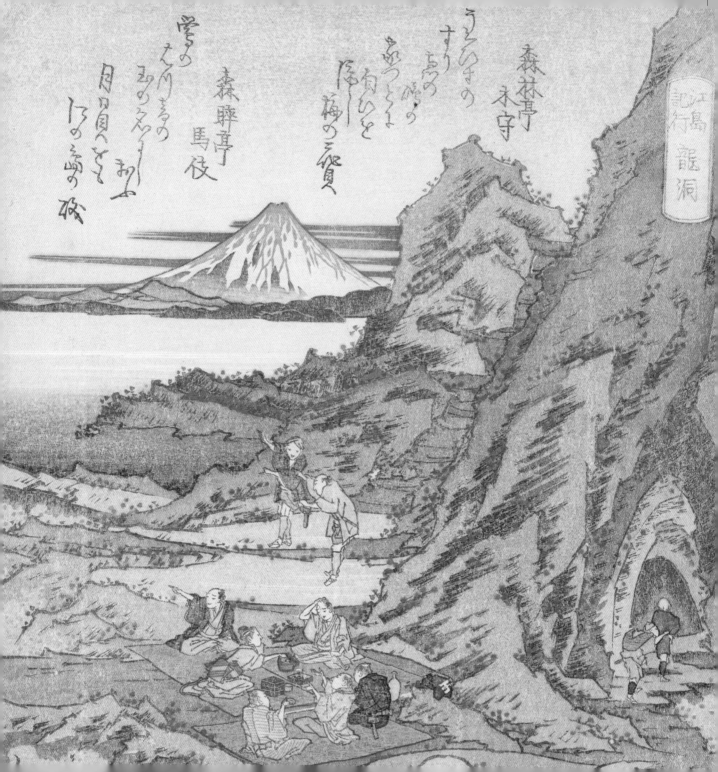

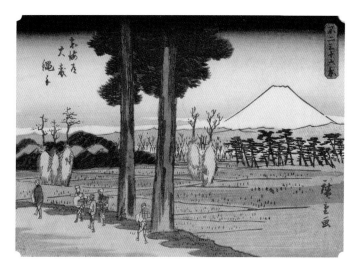

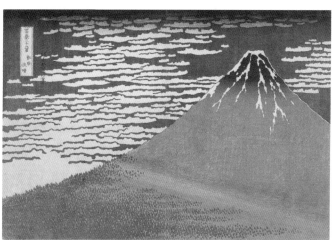

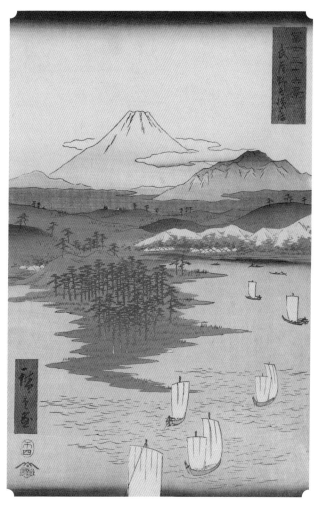

LEFT 1852, Utagawa Hiroshige, *Nawate at Omori on the Tokaido,* from the series *Thirty-six Views of Mount Fuji.*

BELOW 1858, Utagawa Hiroshige, *Yokohama at Noge in Musashi Province,* from the series *Thirty-six Views of Mount Fuji.*

FACING PAGE 1833, Totoya Hokkei, *Ryudo* (detail), from the series *Record of a Journey to Enoshima.*

ABOVE, BOTTOM Also known as "Red Fuji," this is one of Hokusai's most admired works. Ca. 1830–1831, Katsushika Hokusai, *Fine Wind, Clear Weather,* from the series *Thirty-six Views of Mount Fuji.*

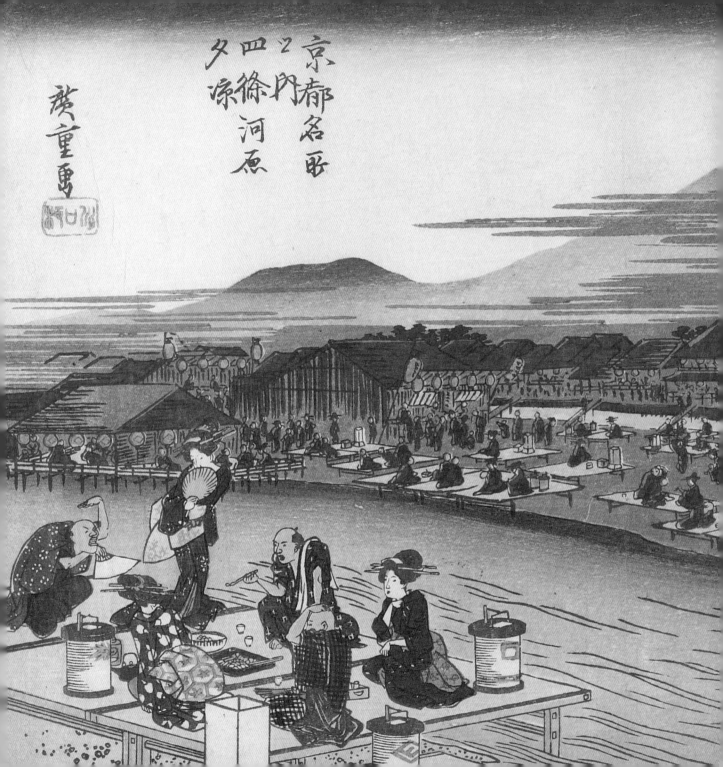

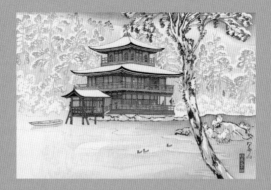

Sights of Kyoto

The city of Kyoto was Japan's imperial capital for more than a thousand years and is the cultural and historic heart of the country. With hundreds of temples and shrines, several entertainment areas, and a renowned cuisine, Kyoto attracted many visitors during the Edo period. Many of Japan's traditional arts, such as kabuki, originated here and were only later transmitted to Edo.

OLD KYOTO

Kyoto, also known as Kyo or Miyako, was the seat of the imperial court from 794 until 1869, when the court moved to Tokyo. The city has an exceptionally large number of historic buildings compared to other Japanese cities, as it was spared bombing during the Second World War. As a result the city has no fewer than seventeen World Heritage Sites.

Kyoto was a popular destination for visitors during the Edo period, most of them arriving via the coastal Tokaido highway or the inland Nakasendo highway.

PAGE 120 1834, Utagawa Hiroshige, Enjoying the *Cool of Evening on the Riverbed at Shijo,* from the series *Famous Views of Kyoto.*

PAGE 121 1924, Miki Suizan, *Snow at the Temple of the Golden Pavilion,* from the series *New Selection of Famous Places of Kyoto, First Collection.*

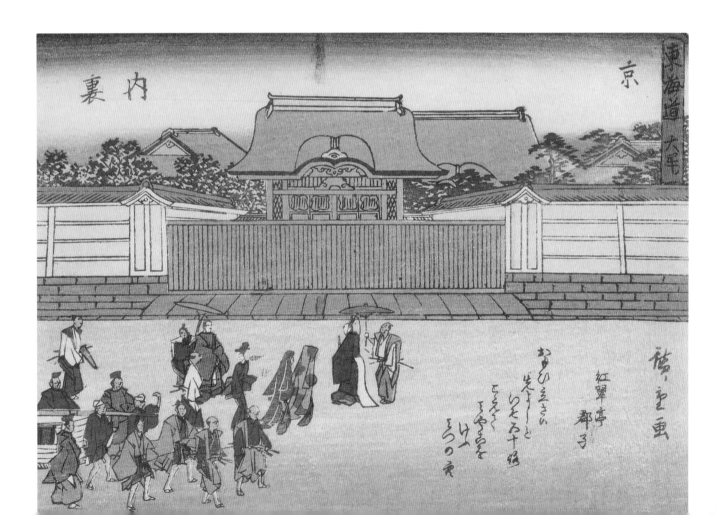

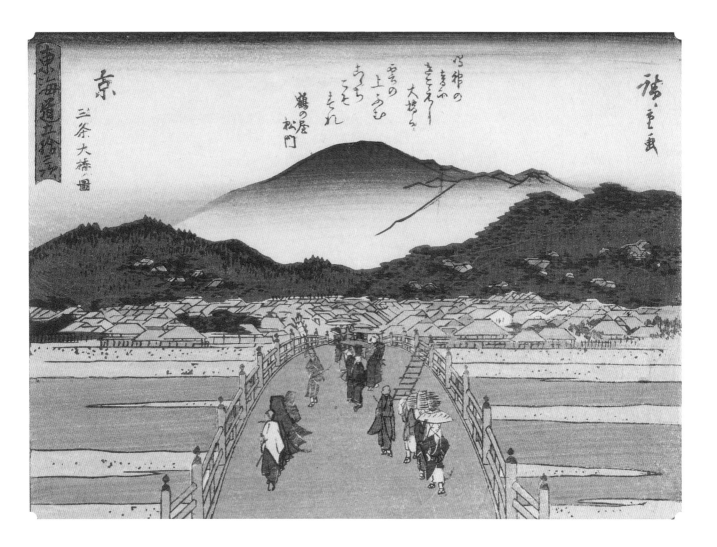

FACING PAGE The Kyoto Imperial Palace has burnt down many times and the current version was built in 1855. The palace is open to the public and can be visited with advance permission. 1840, Utagawa Hiroshige, *Kyoto: The Imperial Palace*, from the series *Tokaido*.

ABOVE A front-on view of the Great Sanjo Bridge, facing in the direction of the city of Kyoto. 1840, Utagawa Hiroshige, *The Great Bridge at Sanjo* (detail), from the series *The Fifty-three Stations along the Tokaido*.

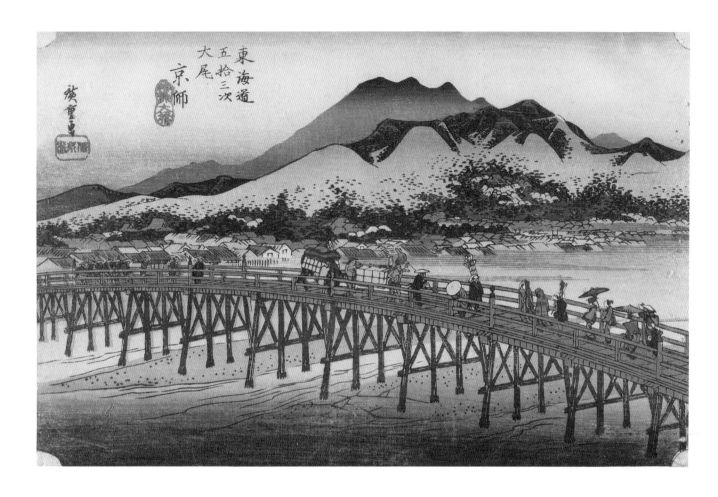

東海道
五拾三次
大尾
京師

ABOVE In the Edo period, this bridge over the Kamo River was considered the entry point to Kyoto and the end of the Tokaido and Nakasendo highways. Ca. 1832–1833, Utagawa Hiroshige, *Kyoto: The Great Bridge at Sanjo,* from the series *The Fifty-three Stations along the Tokaido.*

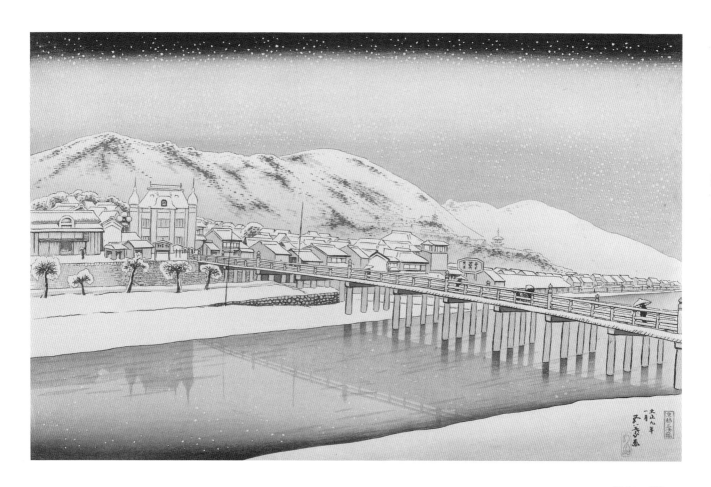

TRADITIONAL PASTIMES

Kyoto is closely associated with traditional pastimes such as kabuki theater, tea ceremony, and blossom viewing. Kabuki originated in Kyoto in the seventeenth century. Woodblock prints often depicted scenes from popular plays such as *Yoshitsune and the Thousand Cherry Trees*, written for the puppet theater in 1747 and adapted to kabuki one year later. It is still considered one of the top three kabuki plays. The fictional story told in fifteen scenes centers on the legendary hero and general Minamoto Yoshitsune (1159–1189) who is fleeing the wrath of his brother.

LEFT Every time Yoshitsune's mistress Shizuka beats a certain drum, a fox spirit appears because the drum was made with his parents' skin. He believes this is the sound of his parents calling him. 1925, Natori Shunsen, *The Actor Bando Shucho III as Shizuka*, from the series *Creative Prints: Collected Portraits by Shunsen*.

FACING PAGE In Act Two, the general Taira Tomomori commits suicide by slinging the rope of a huge anchor around him and plunging into the sea. 1860, Utagawa Kunisada, *Plovers: the Actor Nakamura Shikan IV as Tomomori* (detail), from the series *A Collection of Popular Birds in Accordance with Your Wishes*.

LEFT Kyoto has long been considered the center of the tea-ceremony world, and is also famed for the production of Japanese tea, as much of it is grown in the Kyoto district of Uji. 1884, Toyohara Kunichika, *Umegae*, from the series *Fifty-four Sentiments of the Present*.

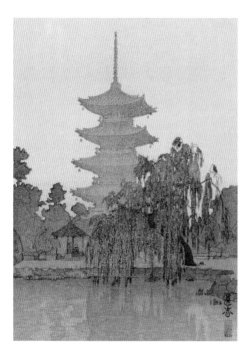

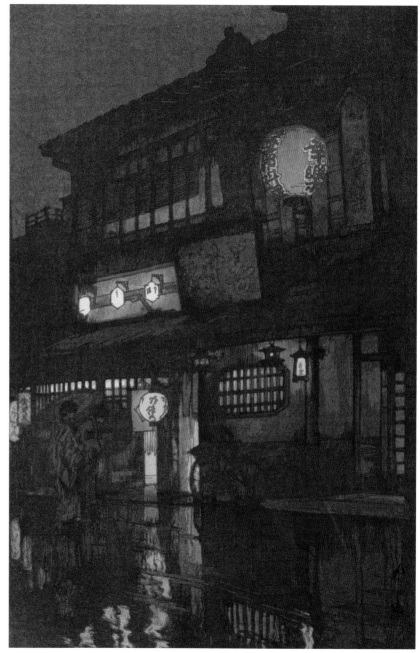

ABOVE The Five-story Pagoda of Kyoto's Toji Temple is the tallest wooden tower in Japan at 180 feet. The current pagoda was built in 1644 and is registered as a National Treasure. Ca. 1942, Yoshida Toshi, *Five-story Pagoda in Kyoto.*

RIGHT Two kimono-clad figures can dimly be seen entering a restaurant. Kyoto cuisine is known for its refined presentation, subtle flavors, and seasonal ingredients.1933, Yoshida Hiroshi, *Night in Kyoto.*

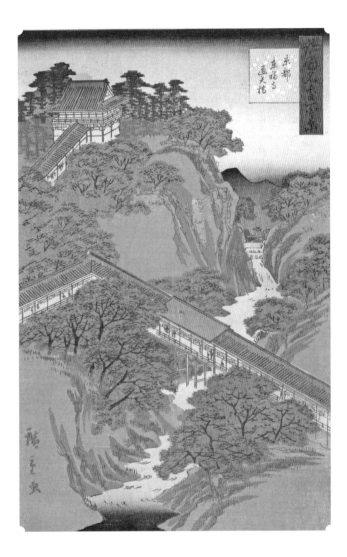

LEFT Kyoto and its environs have always provided plentiful opportunities for the viewing of spring blossoms and autumn leaves. 1859, Utagawa Hiroshige II, *Tsuten Bridge at Kyoto's Tofukuji Temple,* from the series *One Hundred Famous Views in the Provinces.*

RIGHT Mount Yoshino, south of Kyoto in Nara Prefecture, is renowned for its thousands of cherry trees that spawned the saying "hitome senbon," one thousand trees at a glance. The rooftops belong to the Kinpusenji Temple, a registered National Treasure and the second largest wooden building in Japan. Ca. 1833, Katsushika Hokusai, *Cherry Blossoms at Yoshino,* from the series *Snow, Moon and Flowers.*

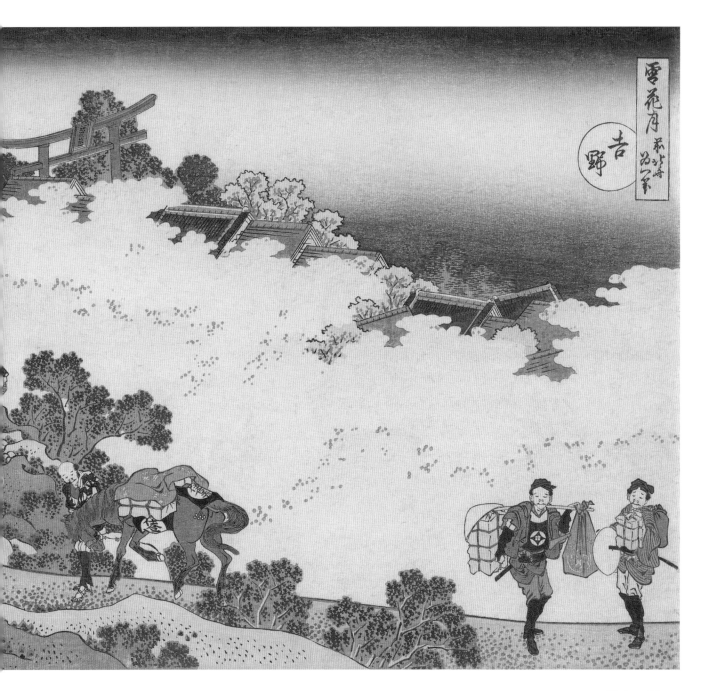

THE GION DISTRICT

Gion is Kyoto's most famous geisha district. The forerunners of the geisha were the twelfth-century *shirabyoshi*, educated female dancers that dressed as men and performed for nobles. In the sixteenth century, the highest ranking courtesans (called *tayu* and then *oiran*) offered not just sexual services—they were also skilled dancers, singers, and musicians. By the mid-eighteenth century the word geisha began to become common for women that were accomplished entertainers.

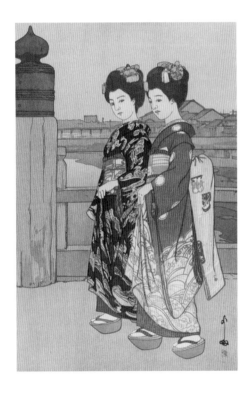

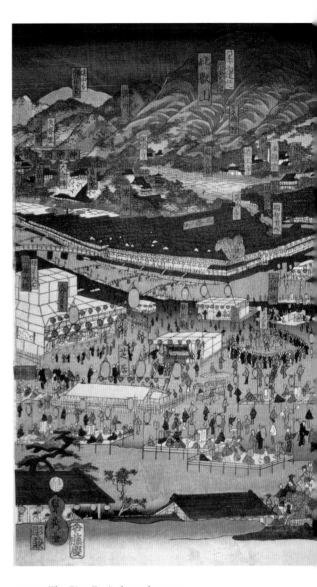

ABOVE Two apprentice geisha dressed in long-sleeved kimono and raised wooden sandals walk across the Great Sanjo Bridge. 1927, Yoshida Hiroshi, *The Great Bridge of Sanjo in Kyoto.*

ABOVE The Gion Festival parade crosses Shijo Bridge on the Kamo River. On the left is the Great Sanjo Bridge; on the right is Gojo Bridge. 1859, Utagawa Sadahide, *Cool Evening at Shijogawara during the Gion Festival in the Imperial Capital.*

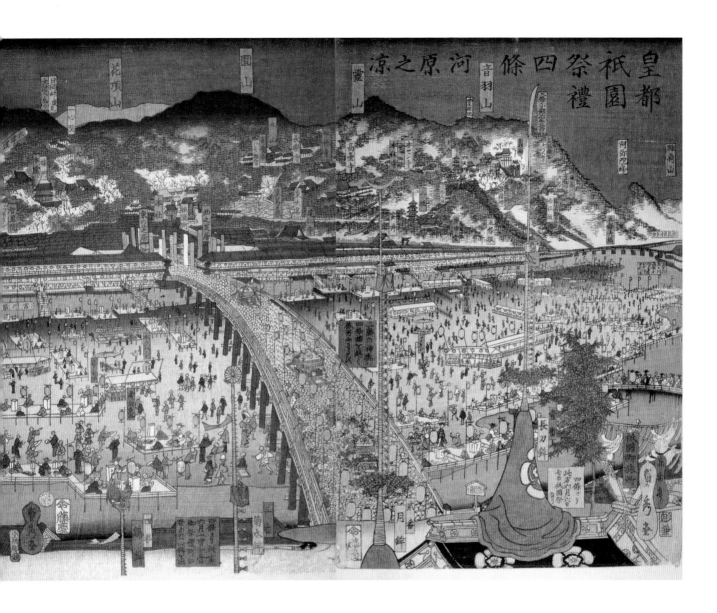

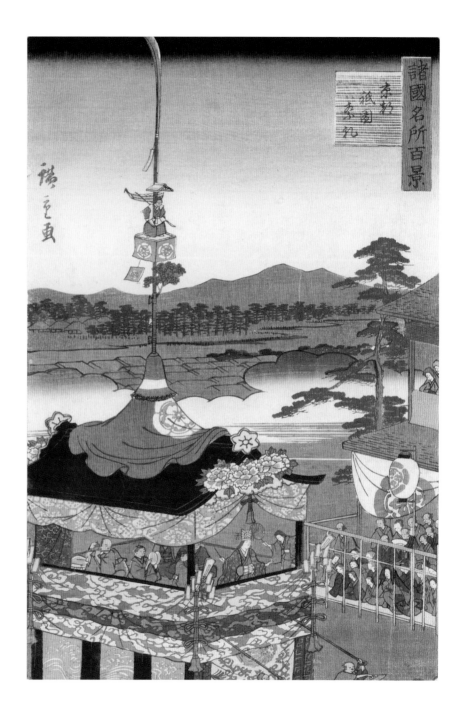

RIGHT A gigantic two-storied float about twenty feet tall and large enough to accommodate several musicians is pulled through the streets. 1859, Utagawa Hiroshige II, *The Gion Festival in Kyoto,* from the series *One Hundred Famous Views in the Various Provinces.*

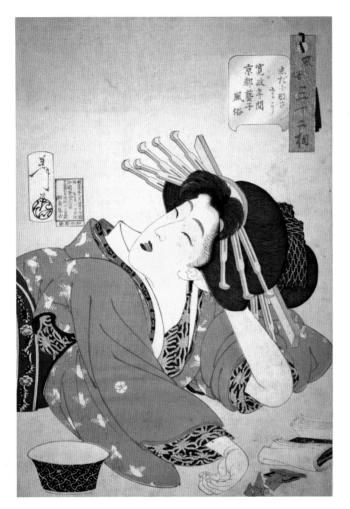

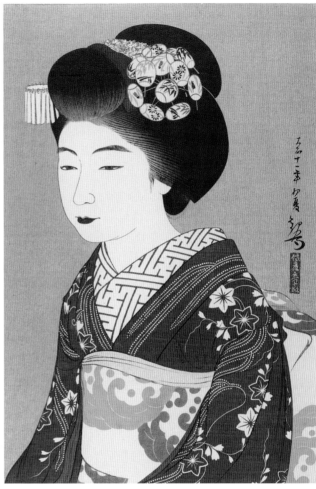

ABOVE A Kyoto geisha from the Kansei era (1789–1801) is portrayed as having fallen asleep while making the small origami figures that can be seen in front of her. 1888, Tsukioka Yoshitoshi, *Looking Relaxed*, from the series *Thirty-two Aspects of Customs and Manners*.

ABOVE Hinazo was a *maiko*, an apprentice geisha typically associated with Kyoto, where the artist Yoshikawa Kanpo was born and lived. 1922, Yoshikawa Kanpo, *Hinazo*, from the series *Selection of Kanpo's Creative Prints, First Collection*.

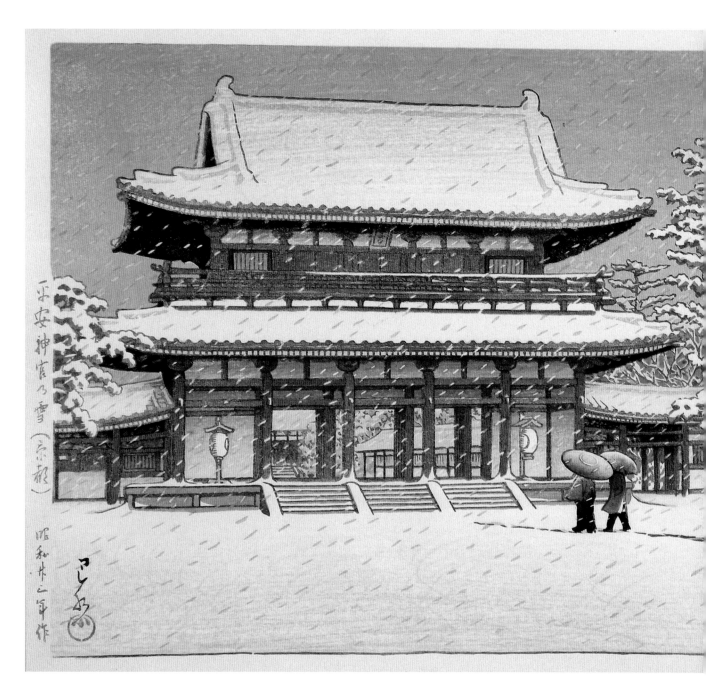

平
安
神
宮
乃
雪
（
京
都
）

昭
和
廿
二
年
作

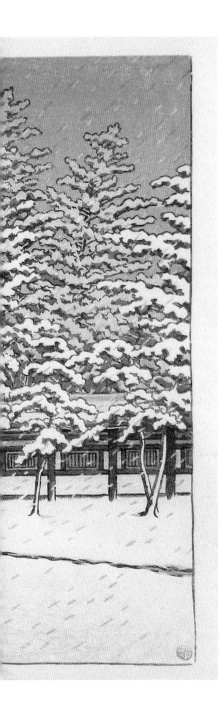

THE HEIAN SHRINE

The Heian Shrine was built at the end of the nineteenth century to celebrate the 1100th anniversary of the founding of the city of Heian Kyo (Kyoto). The architectural style of the shrine replicates the Imperial Palace of the Heian period (794–1185). The shrine is well known for its gardens and for the Jidai Matsuri, one of Kyoto's most important festivals, held every autumn, in which portable shrines are carried through the streets from the old Imperial Palace to the shrine. The shrine is listed as an Important Cultural Property of Japan.

LEFT 1948, Kawase Hasui, *Snow at Heian Shrine (Kyoto).*

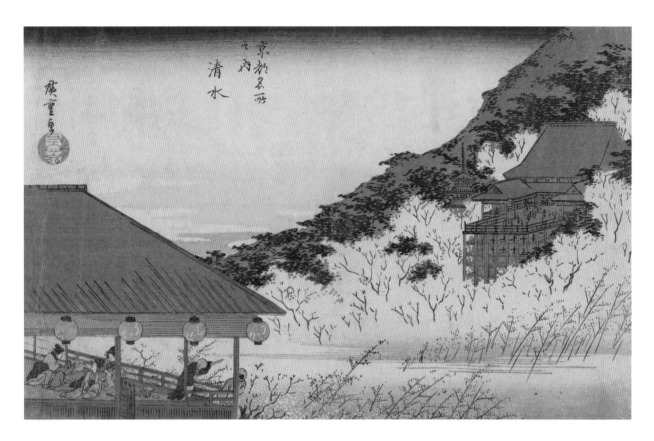

ABOVE Kiyomizu Temple remains to this day a famous cherry blossom viewing spot. Ca. 1834, Utagawa Hiroshige, *Kiyomizu Temple,* from the series *The Famous Places of Kyoto.*

RIGHT The view from the 43-foot-high stage of the main hall of Kiyomizu Temple, which sits on a cliff. 1933, Kawase Hasui, *Kiyomizu Temple in Kyoto*, from the series *Collected Views of Japan II, Kansai Edition.*

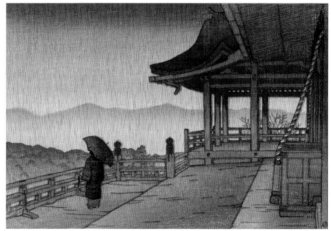

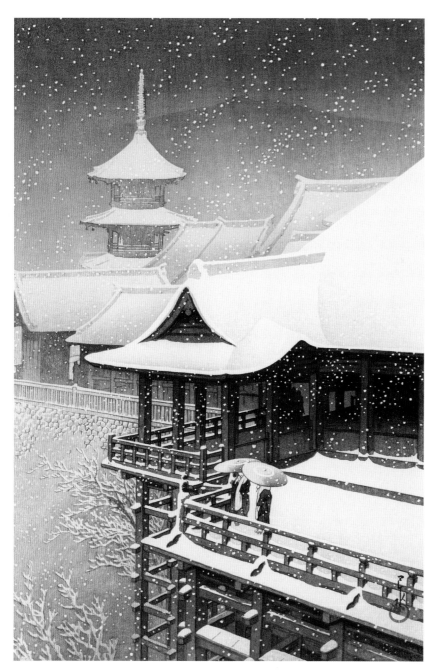

KIYOMIZU TEMPLE

Kiyomizu Temple, founded in 778, is one of the most famous in Japan. It has been destroyed by fire several times and the current buildings date from the early 1630s. Built on 40-foot-high pillars of zelkova wood, the verandah of the main hall extends over a precipice, providing a magnificent view of the city that is enhanced by cherry blossoms in spring and colorful leaves in autumn.

LEFT The main hall of Kiyomizu Temple, known as Kiyomizu Stage, was constructed without the use of a single nail. 1932, Kawase Hasui, *Spring Snow,* **Kiyomizu Temple in Kyoto.**

KINKAKUJI TEMPLE

The Zen Buddhist temple Rokuonji, also known as Kinkakuji, is home to a pavilion whose top two stories are covered with pure gold leaf, known as the Golden Pavilion. Originally a villa, the pavilion became a temple in 1397 and houses Buddhist relics. The original pavilion was burnt down by a novice monk in 1950 and the current structure dates from 1955.

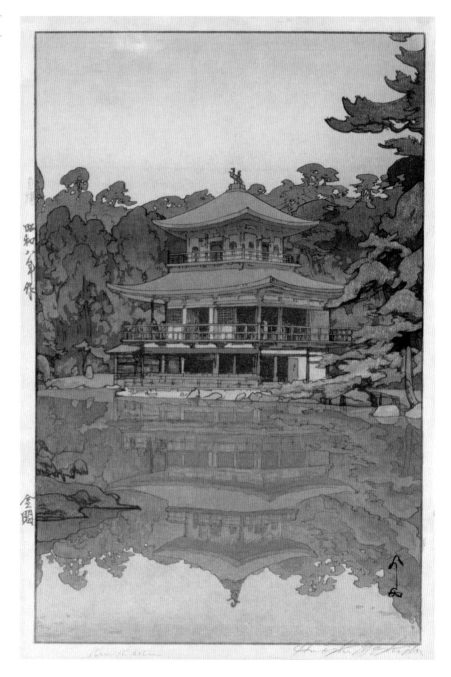

RIGHT This tranquil rendition of the Golden Pavilion tones down its glittering façade. The temple's reflection in the greenish water of the Mirror Pond is also subdued. 1933, Yoshida Hiroshi, *The Golden Pavilion*.

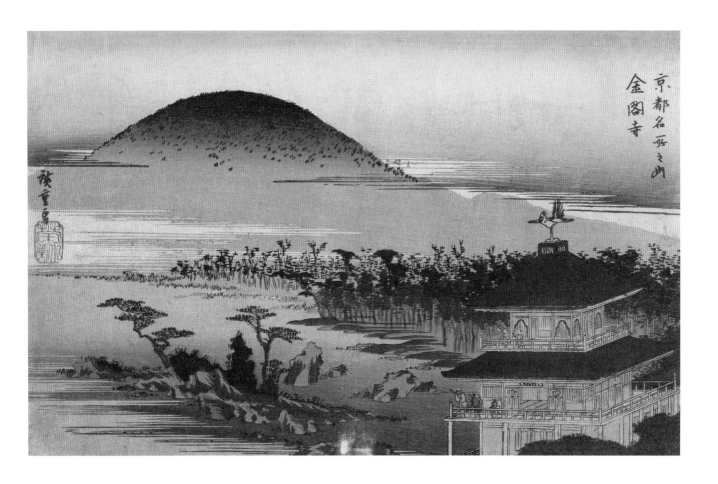

京都名所之内
金閣寺

ABOVE The gardens of this temple are regarded as a fine example of garden design of the Muromachi period (1392–1593). Ca. 1834, Utagawa Hiroshige, *The Temple of the Golden Pavilion,* from the series *The Famous Places of Kyoto.*

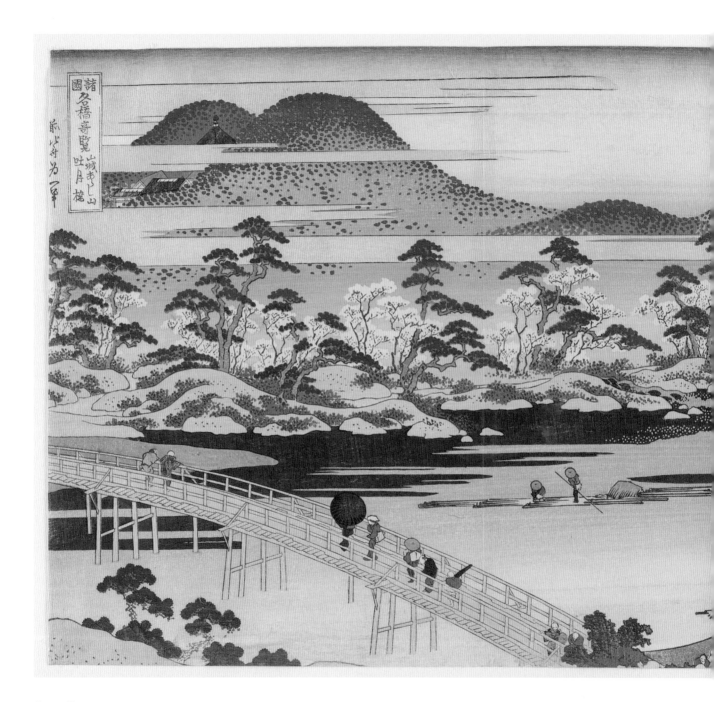

ARASHIYAMA

Removed from the tourist-clogged streets of central Kyoto, the district of Arashiyama is located to the west of the city and has been a favored place of retreat and tranquility since the Heian period (794–1185). Scattered with small temples, shops, and restaurants, it is also a prime spot for viewing cherry blossoms in the spring and colorful leaves in the fall.

LEFT Visitors enjoy a vista of cherry trees from the bridge. Ca. 1834, Katsushika Hokusai, *The Togetsu Bridge at Arashiyama in Yamashiro Province*, from the series *Remarkable Views of Bridges in Various Provinces*.

BELOW The Oi River rushes past an embankment filled with cherry blossoms on the western edge of Kyoto. Ca. 1834, Utagawa Hiroshige, *Full Bloom at Arashiyama*, from the series *The Famous Places of Kyoto.*

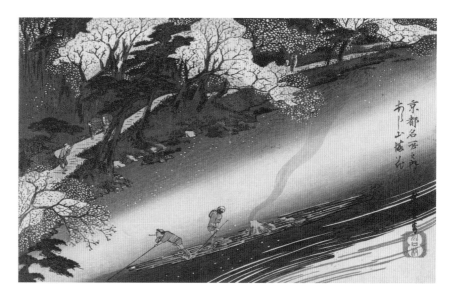

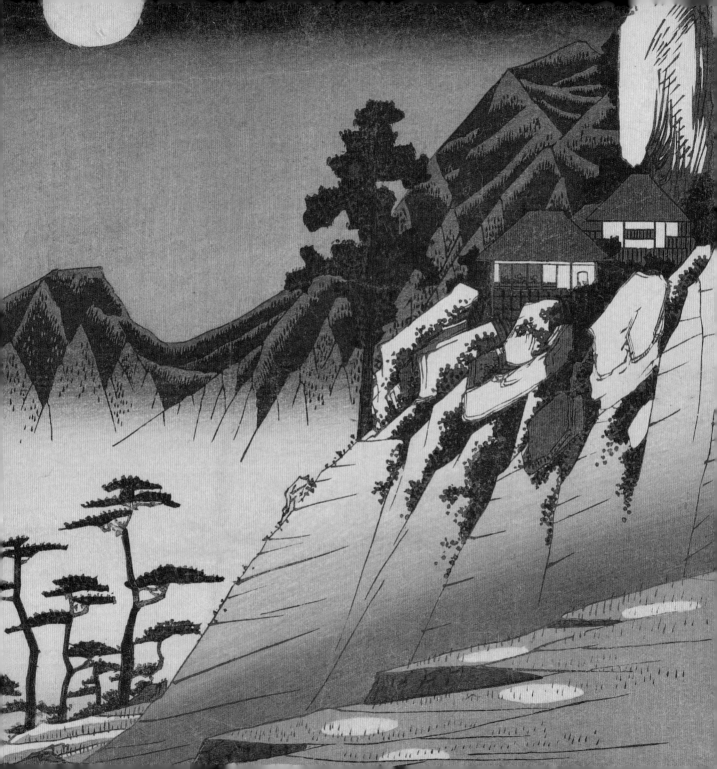

Sights of Japan

Beyond the major cities, Japan is blessed with many attractive natural sights that have long been favorite destinations for domestic and foreign sightseers. Not all locations that are popular today, however, are represented in woodblock prints. Places such as Hiroshima, for example, only became a tourist spot in the second half of the twentieth century.

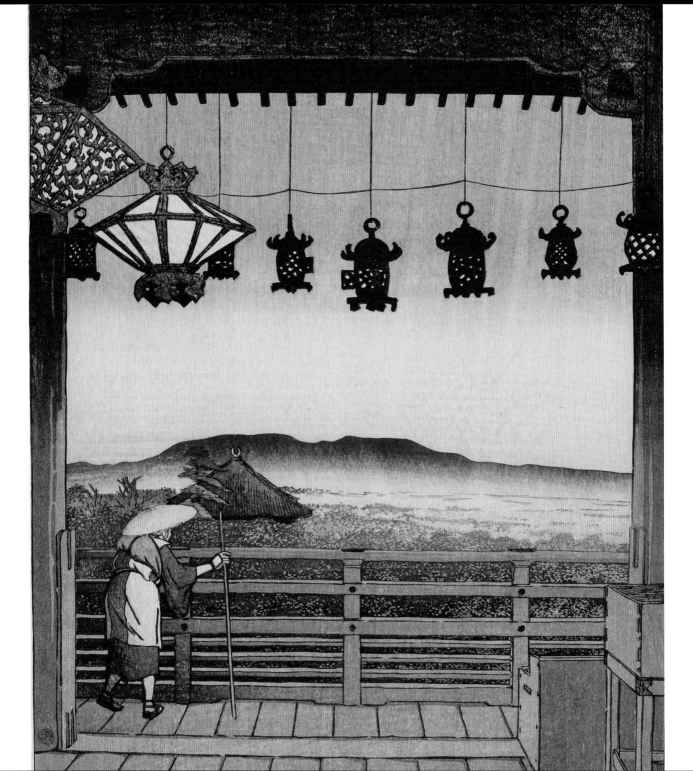

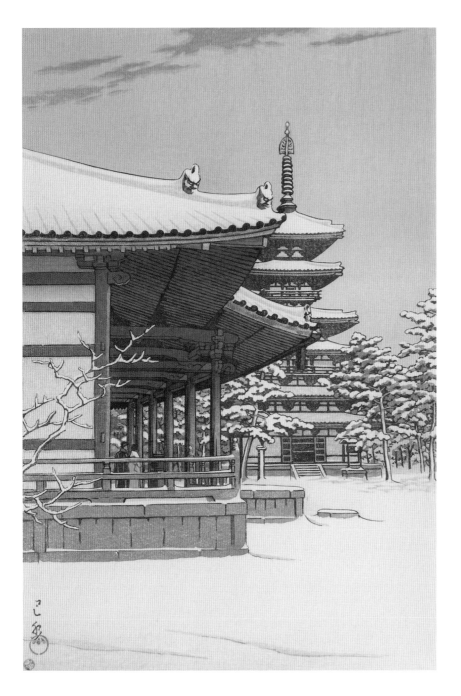

NARA

Nara was Japan's capital from 710 until 784, a period that saw the establishment of Buddhism, and as a result many of the country's oldest and most important temples are located here. But the city is south of Kyoto and was not on the Edo-period network of highways. It was not therefore a popular travel destination, rarely featuring in woodblock prints.

PAGE 144 Ca. 1832–1839, Utagawa Hiroshige, *The Moon Reflected in Rice Paddies at Sarashina in Shinano Province* (detail), from the series *Famous Places of Our Country.*

PAGE 145 1942, Yoshida Toshi, *Shirasagi Castle.*

FACING PAGE 1921, Kawase Hasui, *Nigatsu Hall, Nara* (detail), from the series *Souvenirs of Travel, Second Collection.*

THIS PAGE 1951, Kawase Hasui, *Yakushi Temple, Nara.*

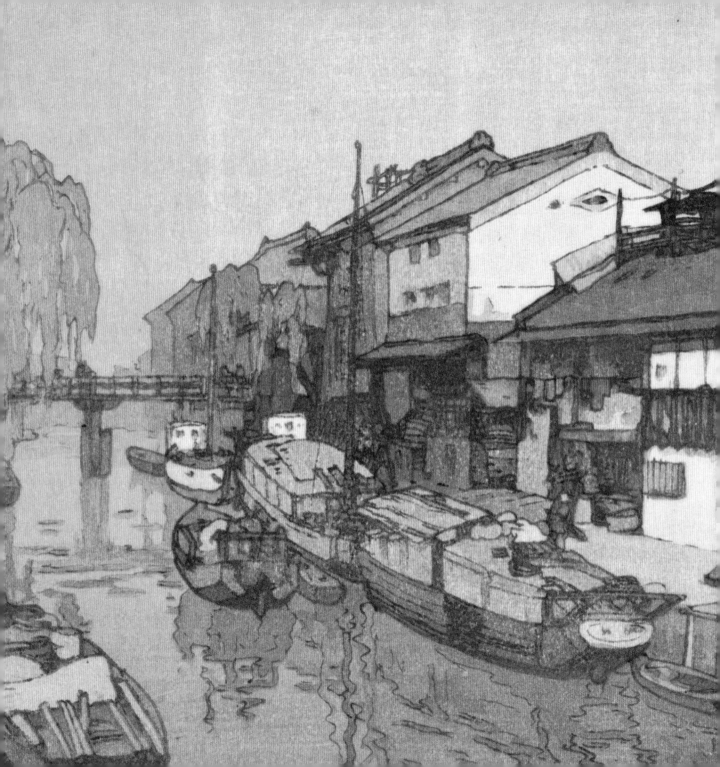

OSAKA

Also known as Naniwa in the Edo period, Osaka has historically been the financial and commercial center of Japan. A favorite subject for woodblock prints was Mount Tenpo (Tenpozan), a 65-foot-high man-made hill constructed in 1831. In modern-day Osaka the hill has been reduced to a 15-foot-high plain, home to Mount Tenpo Park.

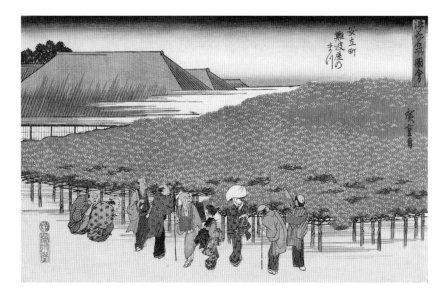

FACING PAGE The city of Osaka is scattered with a network of canals that were built between the late sixteenth and late seventeenth century. 1941, Yoshida Hiroshi, *Canal in Osaka* (detail).

THIS PAGE. TOP This pine tree with its spreading branches in the garden of a teahouse was a popular destination for tourists. 1834, Utagawa Hiroshige, *The Naniwaya Pine in Adachi-cho*, from the series *Pictures of Famous Places in Osaka*.

THIS PAGE. BOTTOM At a lookout point on the Aji River people can squeeze through the holes in two thick pillars, an auspicious tradition copied from the Great Buddha Hall of the Todai Temple in Nara. 1834, Yashima Gakutei, *Osaka's Aji River from the Rain Shelter on Mount Tenpo*.

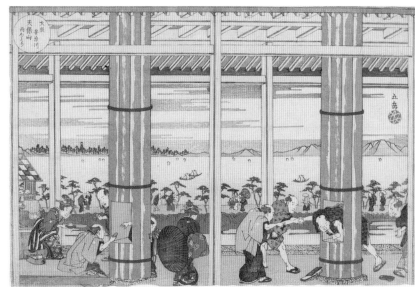

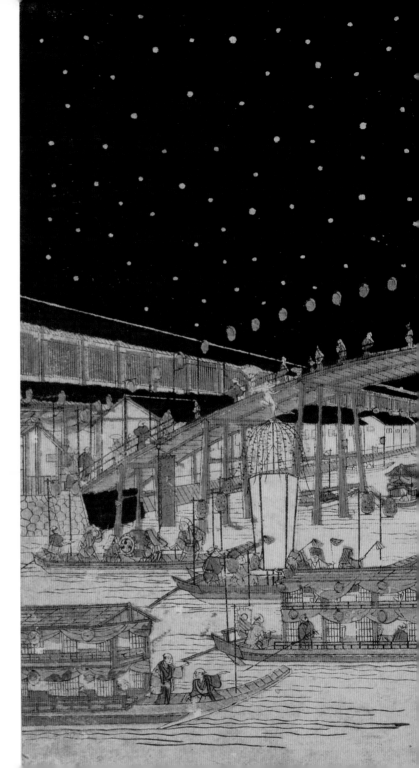

RIGHT Shrines in Japan that bear
the name Tenmangu are devoted to
the scholar and politician Sugawara
Michizane (845–903), known as the
"god of knowledge." All of these
temples celebrate the Tenjin festival
annually in July. The most famous of
these is in Osaka, where the festival
originated in 951. At the height of the
Tenjin Festival boats full of musicians
and dancers sail under the Tenma
Bridge, which is lined with lanterns.
Mid-1770s, Utagawa Toyoharu,
*Perspective Picture of the Tenma
Tenjin Festival at Night in Osaka*.

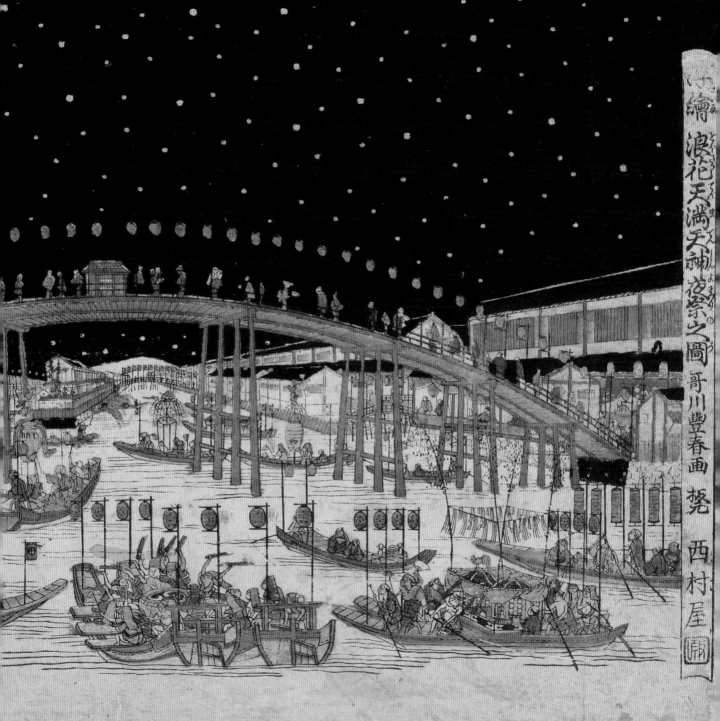

浮繪　浪花天滿天神夜祭之圖　哥川豐春画　板　西村屋

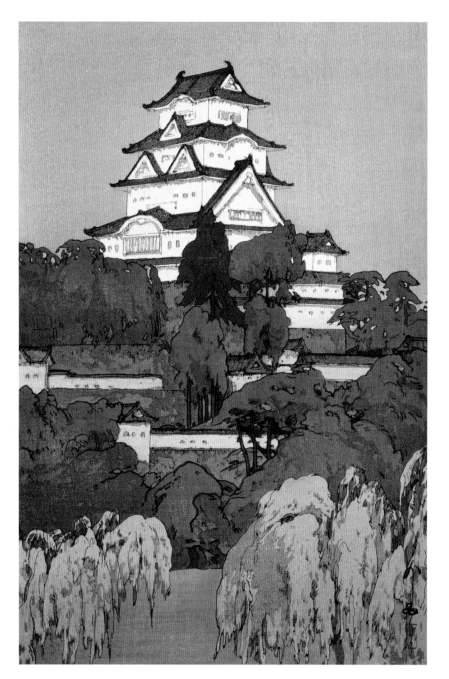

CASTLES

Castles of the Edo period are popular destinations for visitors to Japan today. Early fortifications were designed to be temporary, and were built to defend strategic locations. By the late fifteenth century they had become the homes of feudal lords, which they remained until the end of the nineteenth century when the warrior class was abolished and the castles were turned over to the new government. Many castles were destroyed in World War Two and although they have been rebuilt to have a traditional look, the interiors are modern, concrete constructions.

LEFT Himeji Castle dates from 1333 and was expanded several times until 1618. Undamaged during World War II or by earthquakes, Himeji Castle became a UNESCO World Heritage Site in 1993. 1926, Yoshida Hiroshi, *Himeji Castle*.

FACING PAGE Ca. 1835–1838, Keisai Eisen, *No. 53, Unuma Station: Distant View from Mount Inuyama* (detail), from the series *Kisokaido*.

ITSUKUSHIMA

The island of Itsukushima in Hiroshima Prefecture is popularly known as Miyajima ("shrine island") for its famous shrine, established in the twelfth century, and now one of Japan's most iconic images. The shrine has been listed as a World Heritage Site since 1996.

BELOW A colorfully decorated boat with musicians playing classical court music (*gagaku*) sails off the shore of Itsukushima Shrine. *1830s*, Yashima Gakutei, **Picture of the Kangyo Festival in Itsukushima in June**.

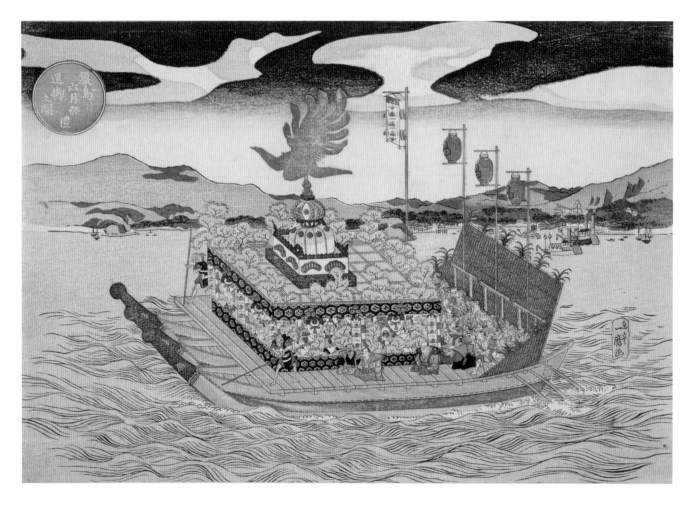

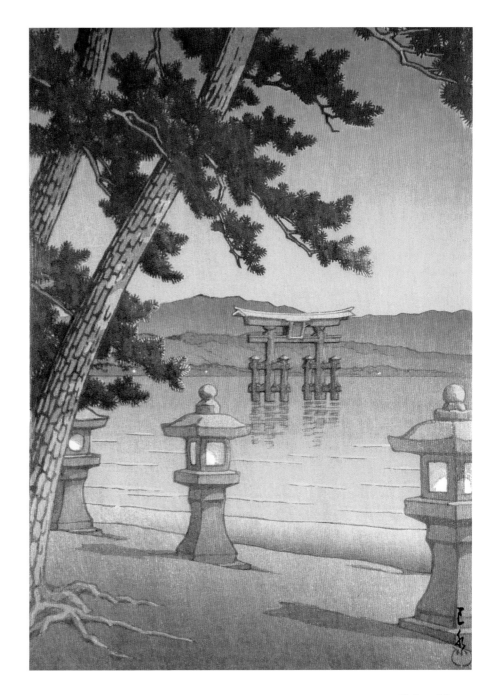

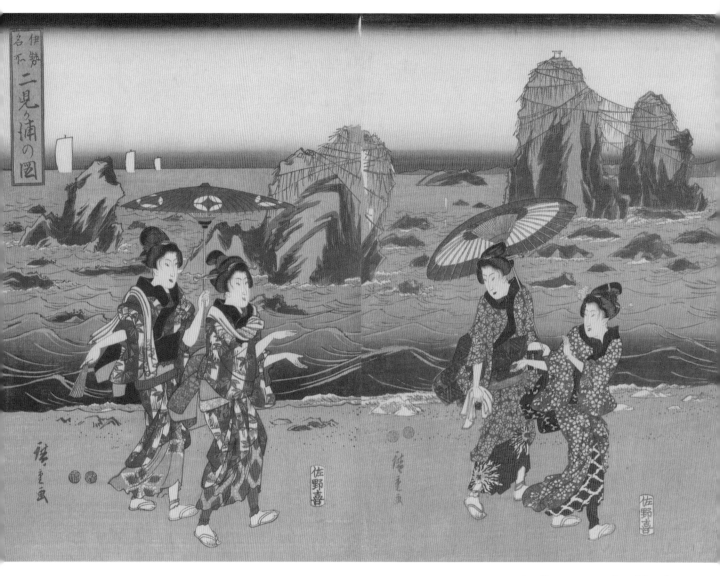

ABOVE Young women take a sightseeing stroll along the beach at Futami. The Wedded Rocks can be seen in the background. Ca. 1849–1851, Utagawa Hiroshige, *Picture of the Coast off Futami*, from the series *Famous Places in Ise*.

THE WEDDED ROCKS OF FUTAMI

In the ocean off the coast of the town of Futami in present-day Mie Prefecture are two sacred rocks, known as Meoto Iwa or "wedded rocks." Joined by a heavy rope of rice straw (*shimenawa*), the rocks represent the union of the gods Izanagi and Izanami, the sacred creators of Japan, according to Shinto belief. The larger, "male" rock has a small *torii* gate at its peak. Dawn during the summer is a favorite time to visit as the sun then appears to rise between the rocks and Mount Fuji might be visible in the distance. The rocks have always been a popular attraction for pilgrims visiting the nearby Grand Shrine of Ise, one of Shinto's holiest locations.

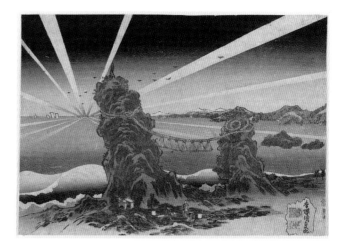

ABOVE This composition, with the Wedded Rocks as giants and the visitors as dwarfs, is not to scale; the rocks are smaller in reality. Ca. 1832, Utagawa Kunisada, *Picture of Dawn at the Coast off Futami*, from an untitled series of landscapes.

OTHER SCENIC HIGHLIGHTS

Attractive locations outside Edo that were not along the popular Tokaido are illustrated in single prints, or in series that feature the provinces, such as *Famous Sights in the Sixty-odd Provinces* (1853–56) by Utagawa Hiroshige. The realism of these pictures is questionable, however, as print artists rarely had the opportunity to travel to remote places, nor is there a tradition in East Asia of painting in the open air. The landscapes depicted in these works are therefore likely to be based on illustrations and descriptions found in travel guide books.

BELOW Sanuki Province, depicted on this fan print, is present-day Kagawa Prefecture on the island of Shikoku. 1856, Utagawa Hiroshige, *View of Zozu Mountain in Sanuki Province.*

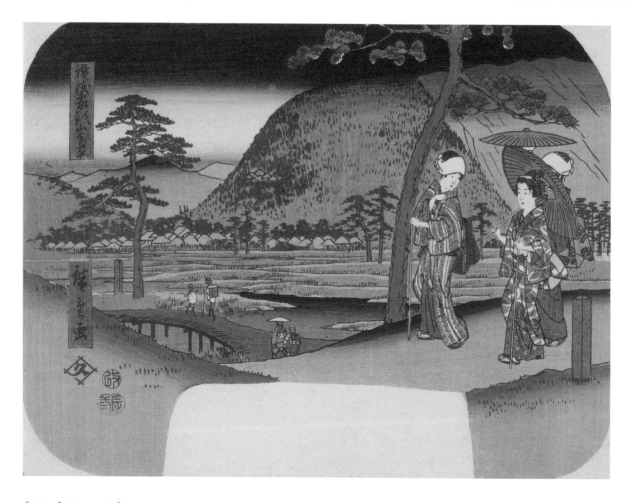

RIGHT The mountainous Shinano Province is present-day Nagano Prefecture. 1853, Utagawa Hiroshige, *Shinano Province: The Moon Reflected in the Sarashina Paddy-fields, Mount Kyodai*, from the series *Pictures of Famous Places in the Sixty-odd Provinces.*

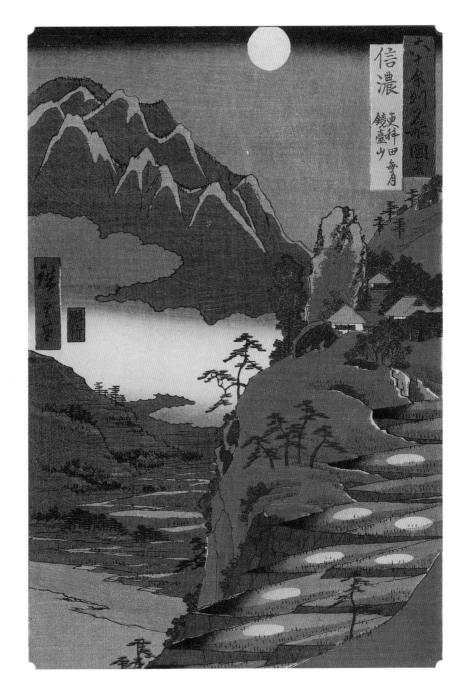

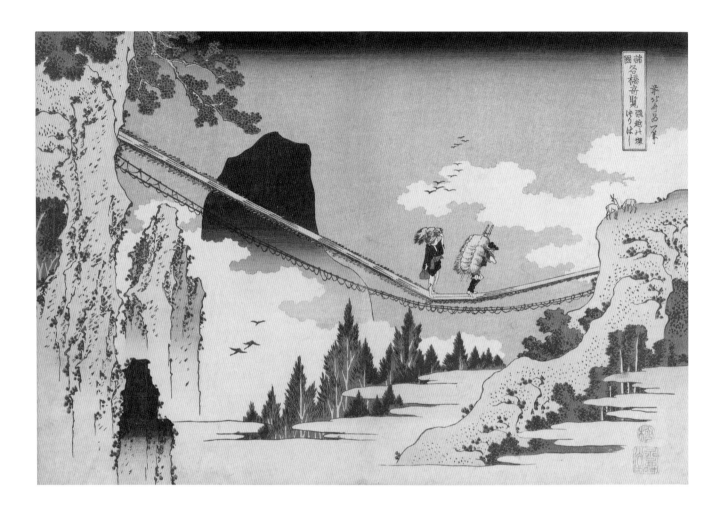

ABOVE Suspension bridges were usually made of vine, which had to be renewed every three years. The give in this bridge makes it look rather precarious. 1834, Katsushika Hokusai, *The Suspension Bridge on the Border of Hida and Etchu Provinces*, from the series *Remarkable Views of Bridges in Various Provinces*.

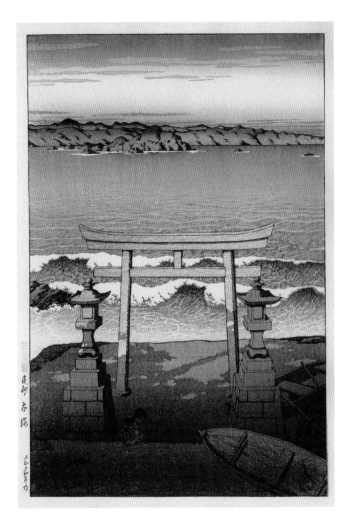

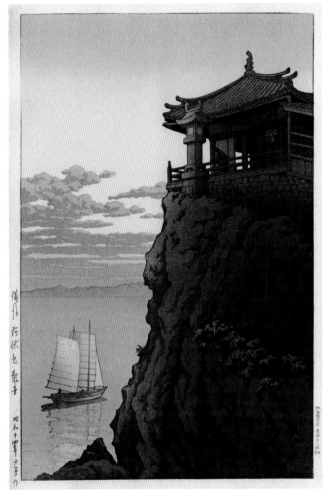

ABOVE Facing Futomi Beach in Kamogawa is Niemonjima, a small island that is today a Chiba Prefecture Designated Place of Scenic Beauty. 1933, Kawase Hasui, *Futomi in Boshu*, from the series *Souvenirs of Travel, Third Collection*.

ABOVE Dedicated to Kannon, the Goddess of Mercy, and founded in 992, Bandai Temple sits on a high cliff overlooking the sea at Fukuyama, Hiroshima Prefecture. 1939, Kawase Hasui, *Abuto Kannon in Bingo*.

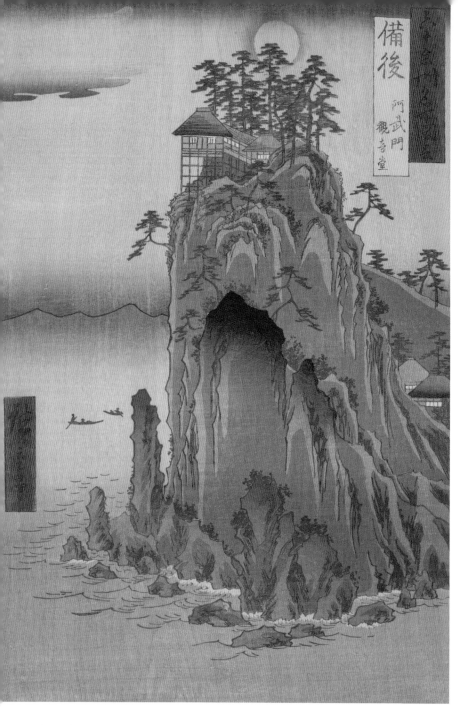

備後

阿武門
観音堂

LEFT Located near Hiroshima, this temple has a high vantage point overlooking the Inland Sea. 1853, Utagawa Hiroshige, *Bingo Province: Abuto, Kannon Temple*, from the series *Pictures of Famous Places in the Sixty-odd Provinces*.

TOP The Futago Islands are two of the almost three hundred pine-covered islands that dot Matsushima Bay. The round one is known as Kamejima (turtle island) and the long one as Kujirajima (whale island). 1933, Kawase Hasui, *Futago Island at Matsushima*, from the series *Collected Views of Japan, Eastern Japan Edition*.

BOTTOM Sado Island in the Sea of Japan is part of Niigata Prefecture. It has become well known in recent times as the home of the world famous taiko drumming group Kodo. 1921, Kawase Hasui, *Dawn Snow at the Port of Ogi on Sado Island*, from the series *Souvenirs of Travel, Second Collection*.

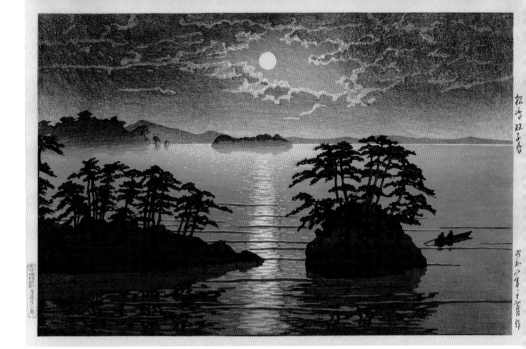

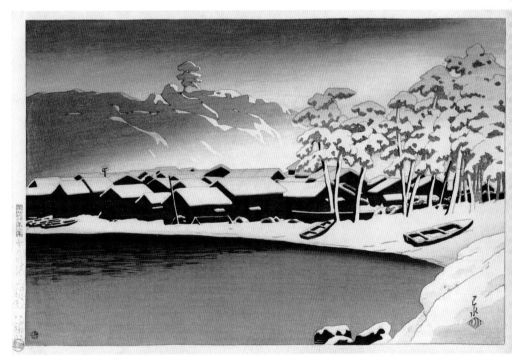

PICTURE CREDITS

All works are woodblock prints; ink and color on paper, unless otherwise specified.
Abbreviations: Minneapolis = Minneapolis Institute of Arts; Honolulu = Honolulu Museum of Art; Scholten = Scholten Japanese Art, New York; Pub = Publisher.
Front cover Pub: Kawaguchiya Shozo. Minneapolis; Bequest of Richard P. Gale 74.1.281. **Back cover** Pub: Takenouchi Magohachi. Minneapolis; Bequest of Richard P. Gale 74.1.261.2. **Front endpaper** Pub: Fujiokaya Keijiro. National Diet Library. **p. 1** Pub: Tsutaya Kichizo. Minneapolis; The Margaret McMillan Webber Estate 51.40.35. **pp. 2–3** Pub: Yamamotoya Heikichi. Honolulu; Gift of James A. Michener, 1991 (21616). **p. 4** Honolulu; Gift of James A. Michener, 1969 (15485). **p. 5** Pub: Sanoya Kihei. Honolulu; Gift of James A. Michener, 1991 (22941). **p. 6** Pub: Takenouchi Magohachi. Minneapolis; Bequest of Richard P. Gale 74.1.265. **p. 8** Pub: Fujiokaya Hikotaro. Minneapolis; Gift of Louis W. Hill, Jr. 81.133.248. **p. 9** Minneapolis; Gift of Louis W. Hill, Jr. P.75.51.171. **pp. 10–11** Pub: Yamamura Kojiro. Honolulu; Gift of Dr. Leslie Wilbur, 1994 (25681). **p. 12** Pub: Sakanaya Eikichi. Minneapolis; Gift of Mrs. Carl W. Jones in Memory of Her Husband P.13,718. **p. 13** Pub: Yamadaya Shojiro. Minneapolis; Gift of Louis W. Hill, Jr. P.75.51.323. **p. 14** © Trustees of the British Museum 1926,0616,0.2. **p. 15** Minneapolis; Bequest of Richard P. Gale 74.1.262. **p. 16** Pub: Sanoya Kihei. Minneapolis; Gift of Louis W. Hill Jr. P.75.51.462. **p. 17** Pub: Fujiokaya Hikotaro. Minneapolis; Bequest of Richard P. Gale 74.1.308. **pp. 18–19** Pub: Tsutaya Kichizo. Collection of Paulette and Jack Lantz. **p. 20** Pub: Fujiokaya Hikotaro. Minneapolis; Gift of Louis W. Hill, Jr. 81.133.243. **p. 21 Pub:** Watanabe Shozaburo. Courtesy THEARTOFJAPAN. COM. **p. 22** Library of Congress. **p. 23** Pub: Yamadaya Shojiro. Minneapolis; Gift of Louis W. Hill Jr. P.75.51.324. **p. 24** Pub: Nishimuraya Yohachi. Minneapolis; Bequest of Richard P. Gale 74.1.314. **p. 25** Pub: Watanabe Shozaburo. Scholten. **pp. 26–27** Honolulu; Gift of James A. Michener, 1957 (14187). **p. 28 (left)** Pub: Enshuya Matabei. Minneapolis; Bequest of Louis W. Hill, Jr. 96.146.221. **pp. 28–29** Pub: Matsumura Tatsuemon. Honolulu; Gift of James A. Michener, 1991 (24637). **p. 30 (left)** Pub: Sakanaya Eikichi. Minneapolis; The Margaret McMillan Webber Estate 51.40.33. **p. 30 (right)** Pub: Watanabe Shozaburo. Scholten. **p. 31** Pub: Watanabe Shozaburo. Honolulu; Anonymous gift, 2006 (28954). **p. 32** Pub: Sakanaya Eikichi. Minneapolis; Gift of Louis W. Hill Jr. P.75.51.378. **p. 33 (left)** Pub: Watanabe Shozaburo. Minneapolis; The Margaret McMillan Webber Estate 51.40.7. **p 33 (right)** Pub: Sakanaya Eikichi. Minneapolis; The Margaret McMillan Webber Estate 51.40.25. **p. 34** Pub: Sakanaya Eikichi. Scholten. **p. 35** Pub: Fujiokaya Hikotaro. Minneapolis; Gift of Louis W. Hill, Jr. 81.133.242. **pp. 36–37** Pub: Maruya Tetsujiro. National Diet Library. **p. 38** Pub: Watanabe Shozaburo. Minneapolis; Gift of Nancy M. Rose 2003.241.14. **p. 39** Pub: Watanabe Shozaburo. Minneapolis; Gift of Ellen and Fred Wells 2002.161.130. **pp. 40–41** Pub: Fukuda Hatsujiro. National Diet Library. **p. 42** Pub: Tsutaya Kichizo. Minneapolis; The Margaret McMillan Webber Estate 51.40.27. **pp. 42–43** Pub: Sanoya Kihei. Minneapolis; Gift of Louis W. Hill, Jr. P.75.51.321. **pp. 44–45** Pub: Iseya Kisaburo. le cabinet japonais / Kotobuki GmbH. **p. 45 (right)** Library of Congress. **p. 46** Pub: Fujiokaya Hikotaro. Minneapolis; Gift of Louis W. Hill Jr. P.75.51.322. **p. 47 (top)** Pub: Fujiokaya Hikotaro. Minneapolis; Gift of Louis W. Hill, Jr. 81.133.249. **p. 47 (bottom)** Pub: Fujiokaya Hikotaro. Minneapolis; Gift of Louis W. Hill, Jr. 81.133.101. **pp. 48–49** Pub: Nishimuraya Yohachi. Courtesy THEARTOFJAPAN.COM. **p. 50** Pub: Watanabe Shozaburo. Scholten. **p. 51** © Trustees of the British Museum. **p. 52** Pub: Fukuda Kumajiro. Honolulu; Gift of James A. Michener, 1959 (28582). **p. 53** Courtesy THEARTOFJAPAN. COM. **p. 54** Minneapolis; Gift of Mrs. Charles B. Meech 91.112.22. **p. 55** Scholten. **p. 56** Pub: Sakanaya Eikichi. Minneapolis; Gift of Louis W. Hill, Jr. P.75.51.314. **p. 57 (left)** Pub: Sakanaya Eikichi. Minneapolis; The Margaret McMillan Webber Estate 51.40.26. **p. 57 (right)** Pub: Tsutaya Kichizo. Minneapolis; Gift of Louis W. Hill Jr. P.75.51.595. **p. 58** Pub: Nishimuraya Yohachi. Minneapolis; Gift of Louis W. Hill, Jr. 81.133.133. **p. 59 (left)** Pub: Sakanaya Eikichi. Minneapolis; Bequest of Richard P. Gale 74.1.285. **p. 59 (right)** Pub: Sakanaya Eikichi. Minneapolis; Gift of Louis W. Hill, Jr. P.78.65.133. **p. 60** Pub: Yamamotoya Heikichi (original edition Nishimuraya Yohachi). Honolulu; Gift of James A. Michener, 1973 (16393). **p. 61 (left)** Pub: Matsuki Heikichi. Honolulu; Gift of James A. Michener, 1957 (13954). **p. 61 (right)** Pub: Hiranoya Shinzo. National Diet Library. **pp. 62–63** Pub: Yorozuya Kichibei. Honolulu; Gift of James A. Michener, 1957 (14188). **p. 64** Library of Congress. **p. 65** Pub: Watanabe Shozaburo. Honolulu; Gift of Mrs. C.M. Cooke, Sr., 1931 (06283). **p. 66** Pub: Kawaguchi and Sakai. Minneapolis; Gift of Paul Schweitzer P.77.28.15. **p. 67** Pub: Watanabe Shozaburo. Scholten. **p. 68** Self-published. Minneapolis; Gift of the Clark Center for Japanese Art & Culture; formerly given to the Center by H. Ed Robison, in memory of his beloved wife Ulrike Pietzner Robison 2013.29.468. **p. 69 (left)** Pub: Sakanaya Eikichi. Honolulu; Gift of James A. Michener, 1991 (24103). **p. 69 (right)** Pub: Sakanaya Eikichi. Honolulu; Gift of James A. Michener, 1991 (22750). **p. 70–71** Pub: Matsuki Heikichi. Minneapolis; Gift of Ruth Lathrop Sikes in memory of her brother Bruce Sikes, 1967 P.13,959a-c. Pub: Sakanaya Eikichi. Library of Congress FP 2 - JPD, no. 1300, p. 8. **p. 73 (left)** Pub: Sakanaya Eikichi. Minneapolis; Gift of Louis W. Hill, Jr. 81.133.115. **p. 73 (right)** Pub: Akiyama Buemon. National Diet Library. **pp. 74–75** Pub: Yokoyama Ryohachi. National Diet Library. **p. 76** © Trustees of the British Museum 1949,0514,0.7. **p. 77 (top)** Pub: Yorozuya Magobei. Collection of Paulette and Jack Lantz. **p. 77 (bottom)** Pub: Fukuda Kumajiro. © Trustees of the British Museum 1946,0713,0.9. **pp. 78–79** LOC FP 2 - Chadbourne, no. 23 a, b, c. **p. 80** Pub: Takenouchi Magohachi. Minneapolis; Gift of Francis W. Little 17.205.31. **p. 81** Pub: Sanoya Kihei. Honolulu; Gift of James A. Michener, 1991 (28775). **p. 82 (left)** Pub: Tsujiokaya Kamekichi. Library of Congress. **p. 82 (right)** Pub: Watanabe Shozaburo. Scholten. **p. 83** Minneapolis; Gift of Louis W. Hill, Jr. P.75.51.203. **pp. 84–85** Pub: Tsujiokaya Kamekichi. Minneapolis; Bequest of Louis W. Hill, Jr. 96.146.103.a-c. **p. 86** Pub: Owariya Seishichi. Library of Congress. **p. 87** Pub: Joshuya Juzo/Jubei. Library of Congress. **pp. 88–89** Pub: Nishimuraya Yohachi. Minneapolis; Bequest of Richard P. Gale 74.1.230. **pp. 90–91** Pub: Iseya Rihei. © Trustees of the British Museum. **p. 92** Pub: Watanabe Shozaburo. Minneapolis; Gift of Gary L. Gliem 2007.107.6. **p. 93** Pub: Tsutaya

Kichizo. Honolulu; Gift of Mrs. C.M. Cooke, Sr., 1934 (10206). **pp. 94–95** Pub: Sumiyoshiya Masagoro. Library of Congress. **p. 96** Pub: Kawaguchi. Minneapolis; Gift of Paul Schweitzer. P.78.28.22 **p. 97** Self-published. Honolulu; Gift of Mrs. Edith G. Manuel, 1943, 1943 (12027a). **p. 98 (top)** Self-published. Minneapolis; Gift of the Clark Center for Japanese Art & Culture; formerly given to the Center by H. Ed Robison, in memory of his beloved wife Ulrike Pietzner Robison 2013.29.463. **p. 98 (bottom)** Self-published. Minneapolis; Gift of the Clark Center for Japanese Art & Culture; formerly given to the Center by H. Ed Robison, in memory of his beloved wife Ulrike Pietzner Robison 2013.29.465. **p. 99 (left)** Minneapolis; Gift of Paul Schweitzer P.77.28.20. **p. 99 (right)** Pub: Kawaguchi. Minneapolis; Gift of Paul Schweitzer P.77.28.17. **p. 100** Pub: Kawaguchi. Honolulu; Gift of Eliza Lefferts and Charles Montague Cooke, Jr., 1941 (11787). **p. 101** Pub: Watanabe Shozaburo. Scholten. **p. 102** Pub: Yamamotoya Heikichi, Honolulu; Gift of James A. Michener, 1957 (13792). **p. 103 (left)** Pub: Yamamotoya Heikichi. Honolulu; Gift of Louis W. Hill, Jr. 81.133.198. **p. 103 (right)** Pub: Akiyama Buemon. Minneapolis; Gift of funds from Mr. and Mrs. Samuel H. Maslon P.77.27.3. **p. 104** Pub: Izumiya Ichibei. Honolulu; Gift of James A. Michener, 1991 (28772). **p. 105** Pub: Fujiokaya Hikotaro. Honolulu; Gift of James A. Michener, 1991 (22384). **p. 106 (left)** Self-published. Minneapolis; Gift of the Clark Center for Japanese Art & Culture; formerly given to the Center by H. Ed Robison, in memory of his beloved wife Ulrike Pietzner Robison 2013.29.447. **p. 106 (right)** Pub: Murataya Ichigoro. Honolulu; Gift of Mrs. C.M. Cooke, Sr., 1934 (10156). **p. 107** Pub: Sanoya Kihei. Minneapolis; Bequest of Louis W. Hill, Jr. 96.146.38. **p. 108 (top)** Pub: Fukuda Kumajiro. Honolulu; Gift of James A. Michener, 1957 (14065). **p. 108 (bottom)** Pub: Sanoya Kihei. Honolulu; Gift of James A. Michener, 1991 (22941). **p. 109** Minneapolis; Gift of Louis W. Hill, Jr. P.75.51.190. **p. 110** Pub: Nishimuraya Yohachi. Honolulu; Gift of James A. Michener, 1991 (21961). **p. 111** Pub: Nishimuraya Yohachi. Minneapolis; Bequest of Richard P. Gale 74.1.227. **pp. 112–113** Minneapolis; Gift of Louis W. Hill, Jr. P.77.39.7.2. **p. 114** Pub: Nishimuraya Yohachi. Minneapolis; Bequest of Richard P. Gale 74.1.236. **p. 115 (top)** Pub: Enshuya Matabei. Honolulu; Gift of James A. Michener, 1987 (20073). **p. 115 (bottom)** Pub:

Maruya Jinpachi. Honolulu; Gift of James A. Michener, 1991 (22487). **p. 116** Pub: Ezakiya Kichibei. Minneapolis; Gift of Louis W. Hill, Jr. 81.133.219. **p. 117** Pub: Nishimuraya Yohachi. Minneapolis; Gift of Mrs. Carl W. Jones in Memory of Her Husband P.13,724. **p. 118** Privately published. Minneapolis; Gift of Louis W. Hill, Jr. P.75.51.182. **p. 119 (top left)** Pub: Sanoya Kihei. Honolulu; Gift of James A. Michener, 1991 (22925). **p. 119 (bottom left)** Pub: Nishimuraya Yohachi. Minneapolis; Gift of Louis W. Hill, Jr. P.70.148. **p. 119 (right)** Pub: Tsutaya Kichizo. Minneapolis; Gift of Louis W. Hill Jr. P.75.51.608. **p. 120** Pub: Kawaguchiya Shozo. Minneapolis; Gift of Louis W. Hill, Jr. P.78.65.92. **p. 121** Pub: Sato Shotaro. Honolulu; Gift of James A. Michener, 1984 (19287). **p. 122** Pub: Sanoya Kihei. Minneapolis; Bequest of Louis W. Hill, Jr. 96.146.84. **p. 123** Pub: Sanoya Kihei. Minneapolis; Bequest of Louis W. Hill, Jr. 96.146.83. **p. 124** Pub: Takenouchi Magohachi. Minneapolis; Gift of Francis W. Little 17.205.55. **p. 125** Self-published. Minneapolis; Gift of Ellen and Fred Wells 2002.161.9. **p 126** Pub: Watanabe Shozaburo. Honolulu; Gift of Charles Alfred Castle Memorial Collection, 1999 (26570). **p. 127** Collection of the author. **p. 128** Pub: Takegawa Seikichi. Honolulu; Purchase, 1955 (15113.32). **p. 129 (left)** Self-published. Minneapolis; Gift of the Clark Center for Japanese Art & Culture; formerly given to the Center by H. Ed Robison, in memory of his beloved wife Ulrike Pietzner Robison 2013.29.471. **p. 129 (right)** Self-published. Minneapolis; Gift of the Clark Center for Japanese Art & Culture; formerly given to the Center by H. Ed Robison, in memory of his beloved wife Ulrike Pietzner Robison 2013.29.417. **p. 130** Pub: Sakanaya Eikichi. Library of Congress. **p. 131** Minneapolis; Bequest of Richard P. Gale 74.1.216. **p. 132 (left)** Self-published. Minneapolis; Gift of Ellen and Fred Wells 2002.161.50. **pp. 132–133** Pub: Fujiokaya Keijiro. National Diet Library. **p. 134** Pub: Sakanaya Eikichi. © Trustees of the British Museum 1915,0823,0.328.2. **p. 135 (left)** Pub: Tsunajima Kamekichi. National Diet Library. **p. 135 (right)** Pub: Sato Shotaro. Minneapolis; Gift of Ellen and Fred Wells 2002.161.155. **p. 136** Pub: Watanabe Shozaburo. Scholten. **p. 138 (top)** Pub: Kawaguchiya Shozo. Minneapolis; Bequest of Louis W. Hill, Jr. 96.146.260. **p. 138 (bottom)** Pub: Watanabe Shozaburo. Courtesy THEARTOFJAPAN.COM. **p. 139** Pub: Doi Sadaichi. Minneapolis; The Margaret McMillan Webber Estate 51.40.14.

p. 140 Self-published. Minneapolis; Gift of the Clark Center for Japanese Art & Culture; formerly given to the Center by H. Ed Robison, in memory of his beloved wife Ulrike Pietzner Robison 2013.29.419. **p. 141** Pub: Kawaguchiya Shozo. Minneapolis; Bequest of Louis W. Hill, Jr. 96.146.261. **p. 142** Pub: Nishimuraya Yohachi. Minneapolis; Gift of Louis W. Hill, Jr. P.70.154. **p. 143** Pub: Kawaguchiya Shozo. Minneapolis; Gift of Louis W. Hill, Jr. P.75.51.452. **p. 144** Pub: Fujiokaya Hikotaro. Minneapolis; Gift of Louis W. Hill Jr. 81.133.172. **p. 145** Self-published. Minneapolis; Gift of the Clark Center for Japanese Art & Culture; formerly given to the Center by H. Ed Robison, in memory of his beloved wife Ulrike Pietzner Robison 2013.29.470. **p. 146** Pub: Watanabe Shozaburo. Honolulu; Gift of James A. Michener, 1984 (19208). **p. 147** Pub: Watanabe Shozaburo. Scholten. **p. 148** Self-published. Minneapolis; Gift of the Clark Center for Japanese Art & Culture; formerly given to the Center by H. Ed Robison, in memory of his beloved wife Ulrike Pietzner Robison 2013.29.443. **p. 149 (top)** Pub: Kawaguchiya Shozo. Minneapolis; Gift of Louis W. Hill Jr. P.75.51.435. **p. 149 (bottom)** Pub: Shioya Kisuke. Minneapolis; Gift of Ruth Lathrop Sikes in memory of her brother Bruce Sikes, 1967 P.13,905. **p. 150** Pub: Nishimuraya Yohachi. Honolulu; Gift of James A. Michener, 1973 (16507). **p. 152** Self-published. Honolulu; Gift of James A. Michener, 1956 (13734). **p. 153** Pub: Takenouchi Magohachi. Honolulu; Gift of James A. Michener, 1970 (15649). **p. 154** National Diet Library. **p. 155** Pub: Watanabe Shozaburo. Scholten. **p. 156** Pub: Sanoya Kihei. Courtesy THEARTOFJAPAN.COM. **p. 157 (right)** Pub: Yamaguchiya Tobei. Honolulu; Gift of James A. Michener, 1959 (14446). **p. 158** Pub: Unidentified (Kyu). Uchiwa-e. Minneapolis; Gift of Louis W. Hill, Jr. P.78.65.70. **p159** Pub: Koshimuraya Heisuke. Minneapolis; Gift of Louis W. Hill, Jr. P.75.51.688. **p. 160** Pub: Nishimuraya Yohachi. Minneapolis; Bequest of Richard P. Gale 74.1.219. **p. 161 (left)** Pub: Watanabe Shozaburo. Scholten. **p. 161 (right)** Pub: Watanabe Shozaburo. Scholten. **p. 162** Pub: Koshimuraya Heisuke. Minneapolis; Gift of Louis W. Hill, Jr. P.75.51.677. **p. 163 (top)** Pub: Watanabe Shozaburo. Scholten. **p. 163 (bottom)** Pub: Watanabe Shozaburo. Scholten. **p. 167** Pub: Fukase Kamejiro. Collection of Paulette and Jack Lantz. **Back endpaper** Pub: Tsutaya Kichizo. Minneapolis; Gift of Louis W. Hill, Jr. P.75.51.198, P.75.51.199, P.75.51.200.

FULL VERSIONS OF CROPPED IMAGES

PAGE 1

PAGE 30

PAGE 118

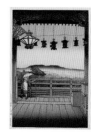

PAGE 146

PAGE 2-3

PAGE 31

PAGE 120

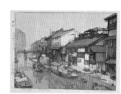

PAGE 148

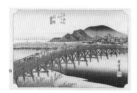

PAGE 6

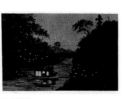

PAGE 61

PAGE 127

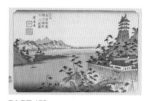

PAGE 153

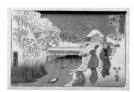

PAGE 13

PAGE 66

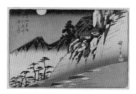

PAGE 144

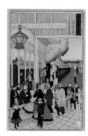

PAGE 167

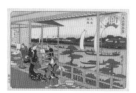

PAGE 20

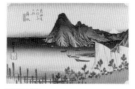

PAGE 80

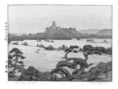

PAGE 145

FACING PAGE Ca. 1875, Utagawa Kunitoshi, *Picture of People Waiting for the Steam Train at Shinbashi Railroad Station* (detail), from the series *The Famous Places in Tokyo.*

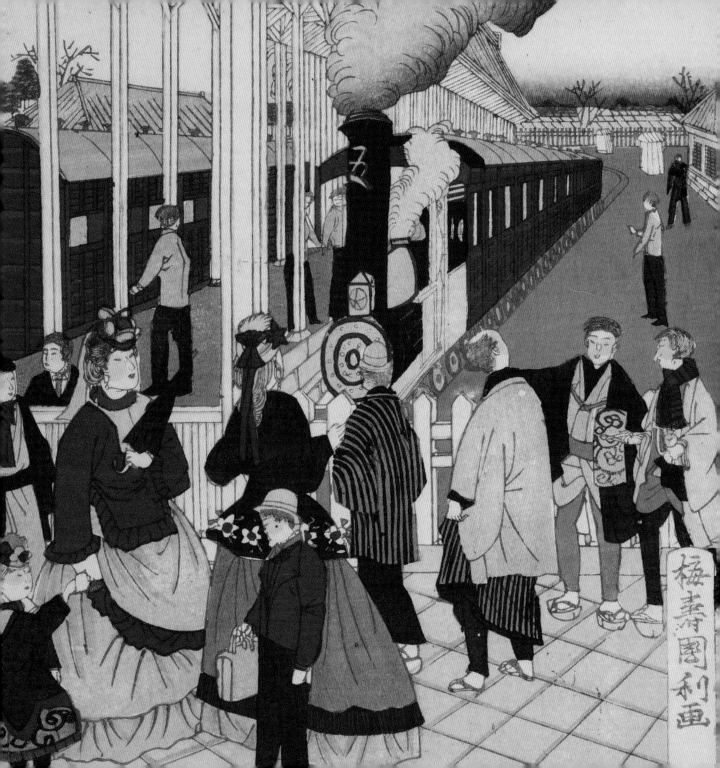

梅寿園利画

Published by Tuttle Publishing, an imprint of Periplus Editions (HK) Ltd.

www.tuttlepublishing.com

ISBN: 978-4-8053-1310-7

Distributed by

North America, Latin America & Europe
Tuttle Publishing
364 Innovation Drive, North Clarendon,
VT 05759-9436 U.S.A.
Tel: (802) 773-8930
Fax: (802) 773-6993
info@tuttlepublishing.com
www.tuttlepublishing.com

Japan
Tuttle Publishing
Yaekari Building, 3rd Floor, 5-4-12 Osaki,
Shinagawa-ku, Tokyo 141 0032
Tel: (81) 3 5437-0171
Fax: (81) 3 5437-0755
sales@tuttle.co.jp
www.tuttle.co.jp

Asia Pacific
Berkeley Books Pte. Ltd.
3 Kallang Sector, #04-01
Singapore 349278
Tel: (65) 67412178
Fax: (65) 67412179
inquiries@periplus.com.sg
www.tuttlepublishing.com

25 24 23 22
10 9 8 7 6 5

Printed in China 2201EP

TUTTLE PUBLISHING® is a registered trademark of Tuttle Publishing, a division of Periplus Editions (HK) Ltd.

"Books to Span the East and West"

Tuttle Publishing was founded in 1832 in the small New England town of Rutland, Vermont [USA]. Our core values remain as strong today as they were then—to publish best-in-class books which bring people together one page at a time. In 1948, we established a publishing office in Japan—and Tuttle is now a leader in publishing English-language books about the arts, languages and cultures of Asia. The world has become a much smaller place today and Asia's economic and cultural influence has grown. Yet the need for meaningful dialogue and information about this diverse region has never been greater. Over the past seven decades, Tuttle has published thousands of books on subjects ranging from martial arts and paper crafts to language learning and literature—and our talented authors, illustrators, designers and photographers have won many prestigious awards. We welcome you to explore the wealth of information available on Asia at **www.tuttlepublishing.com**.

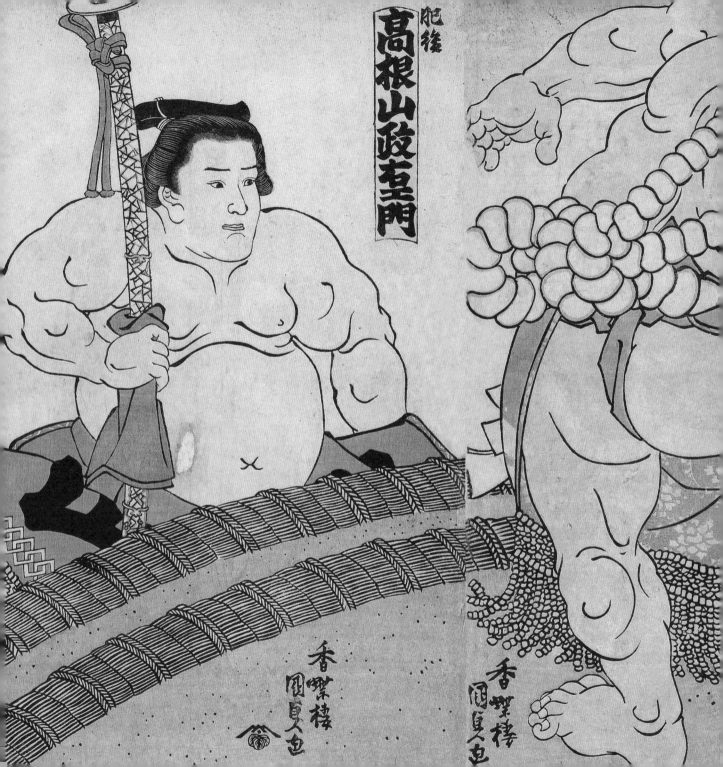

肥後　高根山政右エ門